Experimental Painting

Experimental Painting

construction, abstraction,
destruction, reduction

Stephen Bann

UNIVERSE BOOKS
New York City

Acknowledgments

Acknowledgments are due to the Fitzwilliam Museum, Cambridge, for plates 1, 14, 59; to the National Galleries of Scotland, for plate 2; to the Tate Gallery, London, for plates 33–35; to the Gulbenkian Foundation for plate 40; to the Marlborough Gallery, London, for plates 3–6, 36–39; to the Leo Castelli Gallery, New York, for plate 45; to the Ileana Sonnabend Gallery, Paris, for plates 52, 54, 57; to the Polytechnic Film Section, London, for plate 43, taken from the film *Auto Destructive Art* (1963); to the Galleria Sperone, Turin, for plate 44; to William Schöningh for plate 15; to Jac. ten Brock for plates 16, 17; to the Dutch Goverment for plate 18; to Studio Martin, Paris, for plate 26; to Mrs Lilian Bomberg for plate 46; to Mr Edwin James for plate 47; to Dr Peter Ludwig for plates 48, 56; to Mr and Mrs Robert C. Scull for plate 51; also to the following artists who kindly provided photographs of their work: Martha Boto, Charles Biederman, Joost Baljeu, Victor Vasarely, Yvaral, Bernard Lassus, Gustav Metzger.

First published in London 1970 by
Studio Vista Ltd, Blue Star House, Highgate Hill, London N19
and in the United States of America in 1970
by Universe Books
381 Park Avenue South, New York City, 10016

Set in 11 pt Modern Extended

Made and printed in Great Britain
by Richard Clay (The Chaucer Press) Ltd
Bungay, Suffolk

British SBN 289 79693 8

Library of Congress Catalog Card Number: 79–105961

American SBN 87663–120–0

Contents

Preface

Although this study confronts a problem of extremely wide ramifications, it is at the same time inevitably the sum of the separate interests which have channelled my awareness of contemporary painting over the past ten years. Many of these interests have developed as a result of discussion with friends. I would therefore like to record my debt to three of these in particular—Reg Gadney, Philip Steadman and Michael Weaver. My indebtedness to the magazine *Form*, and consequently to the editorial acumen of the two latter, would in all events be quite clear from the concluding list of sources.

There is no direct system of references between the text and this list of sources. However, the works from which quotations are made are indicated separately according to the division of chapters. Where a quotation is taken from a work of general reference, the page number and, occasionally, the subject involved are included after the date and place of publication.

Canterbury, May 1969 Stephen Bann

Introduction

All painting is in a sense experimental. So we might conclude from a survey of the various historical stages of the painter's attempt to represent reality through his chosen medium. What E.H.Gombrich has termed the process of 'making and matching' must be resumed continually, not only in response to the broader transformations within society, but also on the individual level, with each fresh picture, each new problem attempted. Despite this fact it has become customary to use the word 'experimental' to define the particular quality which distinguishes the art of the twentieth century from that of previous times. Professor Gombrich himself, when he comes to the last chapter of his *Story of Art*, adopts this policy. Under the heading 'Experimental Art: The Twentieth Century', the entire course of Western art and architecture since Cubism is subsumed.

My own study of experimental painting is far from covering either of these limitless fields. On the whole it is concerned with a tradition that belongs to the art of the present century. But its framework of reference is not the Modern Movement considered as an indivisible whole. This is partly because the 'Experimental Art' which Gombrich describes was characterized by a high degree of interchange between the various artistic genres: my own purpose, however artificial this may appear at certain points, is to consider the genre of painting in isolation. A second reason would be that the Modern Movement harboured not merely an experimental tradition but also a tendency associated with such figures as Tatlin and Van Doesburg which was obviously and belligerently anti-experimental, in the sense that it involved the unqualified acceptance of a new 'classical' vocabulary.

These two points are in effect closely connected, since it was precisely the new classical principles which tended to reduce all forms of plastic expression to basic elements, and so obscured the differences between the genres. Such principles were particularly inimical to the fragile status of painting, which has always hinged upon a precarious and seemingly irrational balance between surface and space, two and three dimensions.

My study is therefore concerned both with painting as a traditional genre, and with what I consider to be the genuinely experimental tendency deriving from the Modern Movement. To define this field more closely, I shall now examine the significance of the two key terms.

The idea of experiment, in the first place, can mean anything or nothing in the context of artistic creation. My own definition of the experimental painter is that he is committed to a particular *path* of controlled activity, of which the works which he produces remain as evidence. In other words, the direction in which the artist moves is at least as important as the individual statements which record the track that he has taken. It is hardly necessary to mention that this conception of the artist's work completely cuts across that which has been generally accepted. Constable, who was probably the first painter to feel the attraction of this new mode of

activity, was at the same time quite aware of the conflict which it involved, as I hope to demonstrate in the next chapter. Even as late as 1946, Moholy-Nagy had to explain why he had included so many of his 'earliest experiments' in a retrospective exhibition with the justification: 'Because they were experiments . . . There is nothing more important to me just now than seeing my whole development in retrospect. I want to get a continuous picture of how the relationship of pigment and light, and of line and space, developed.' Perhaps it is only in the past decade, with the New Tendency commitment to 'continual research', that this new conception of the artist's role has been accepted widely.

It follows from this definition that I am concerned with experimental activity rather than with the experimental painting as such. In fact I would seriously doubt whether it is useful to speak of the individual work in this way, without reference to such a form of activity. Jasia Reichardt recently wrote of the works of Peter Schmidt that they were 'in the truest sense experiments since each work consists of new propositions and their unexpected outcome'. But this principle is simply an extension of the necessary indeterminacy involved in any creative process—an antidote to what the late Anton Ehrenzweig referred to as the 'dangers of over-precise visualization' in the plastic arts. The truly revolutionary position in my view is that the 'new propositions' should themselves be linked, and that the individual work may in this way relate to a specific programme.

The 'experimental' procedures which I shall be tracing will therefore approach at their most extreme the scientific analogy of the research worker, whose experiments are valuable only in so far as they can be inserted into an evolving theoretical scheme. At the other end of the scale, this emphasis upon the artist's 'path' need imply very little more than Mondrian meant when he wrote: 'True art like true life takes a single road.'

It remains necessary to provide some indication of the problems which I regard as being specific to the genre of painting. For, just as the constructive artists of the Modern Movement dissolved the problem of pictorial ambiguity by insisting on the two-dimensionality of painting, so their present-day heirs among young artists are liable to deny that there is any essential difference between works in two and three dimensions.

Perhaps it would be fair to say that the genuine painter, however much he may be committed to exploring a particular direction, is continually attempting problems that are equivalent to those of his predecessors. He works not merely with a two-dimensional surface but with the particular presuppositions about pictorial space that have dominated European painting since the Renaissance. Professor Gombrich has tentatively suggested, in *Art and Illusion*, that perspective and the evocation of space have obsessed the art historian for too long, that he has a duty to bring into prominence such neglected aspects of the painter's art as 'the suggestion of light and of texture, or the mastery of physiognomic

expression'. But, however fascinating these fields of study may be, the issue of pictorial space surely continues to intrigue the modern painter in a way that both these other aspects of pictorial art have ceased to do. Since the culminating achievement of pictorial perspective in the unique vanishing point, the painter has been confronted in a particularly acute form with the interdependence of surface and space: whether or not we accept Bishop Berkeley's view—that we 'see' a surface and 'construct' a scene—the need to conciliate two different modes of perception is obvious.

The painter is therefore obliged to confront, in some way or other, the problem of illusion. And the way in which he does so will inevitably involve both his knowledge of perspectival space as it has been used in post-Renaissance painting, and our own disposition to read space of this kind into the most schematic pictorial designs. But I would not wish to imply that the Renaissance pattern is an eternal one, or that there has been no profound change in the quality of pictorial space during the past half-century. Vasarely has rightly placed the problem of illusion on a more general level by emphasizing that: 'The drama and the triumph of the painter has—always—been precisely that of managing the impossible: giving more with less, if you like: giving something other than the plane on the plane. The innumerable pictorial "spaces" of the past . . . testify to the painter's incessant struggle with the plane.' The course of Vasarely's own work is perhaps the best evidence for the kind of transformation within a constant framework of reference that he suggests. From a group of early works in which the suggestion of three-dimensional space is more or less traditional, he has moved to a stage where the plane is no longer a 'window' but an unstable area that is constantly being broken up and reformed.

My account will therefore concentrate upon two particular features which are central to the problem of experimental painting: the notion of the artist's activity as a 'single road' of exploration, and the notion of the painting as 'something other than the plane on the plane'. Most of my material will be drawn from the work of contemporary painters. But there will also be references to the Modern Movement and beyond. In particular, the first chapter is a general introduction to the problem of experiment in painting, no more than touches upon the careers of the artists mentioned.

Note: numbers in brackets in the text refer to plate numbers.

1 The experimental approach: past and present

Experiment in art is very far from being the same thing as experiment in science. For this reason, some have doubted whether the term has any use at all in an artistic context. Frank Malina, a kinetic artist who is also a trained scientist, has recorded ironically:

The word 'experiment' has worked its way into the field of art, with peculiar connotations. If a work of an artist is appreciably different from preceding widely accepted art objects, it is highly probable that the new work will be classified as 'experimental'. Then a miracle may take place, for without the artist modifying his work in any way, with the passage of time it is reclassified as a masterpiece. In the world of art it would perhaps be more appropriate to call the consumers of art 'experimental', since it is they who have so many times modified their view of an artist's work.

Dr Malina's point is answered to a great extent by Professor Gombrich, who insists that the disappearance of a painting's initial 'experimental' status is the very condition of its success. The works of the Impressionists provoked initial resistance on the part of the public, but the fact that they were accepted at a later date establishes the success of the experimental attitude which they originally derived from.

Here is one possible definition of the experiment in art: that it should involve new schemata for representing the world, which eventually become acceptable as the vision of the public is attuned to that of the artist. But my own approach in this chapter presumes a rather different view of experiment. Although this may at first appear paradoxical, my definition of the experimental activity of the painter is that it must be carried on without any possibility of successful resolution. In other words, it is a search which is bound to be self-justifying, since there are no objective criteria for assessing success or failure. It is essentially a deviation from the role of the artist as it is traditionally understood, and so necessarily involves a rejection of scale of the values traditionally applied to what the artist produces.

THE NINETEENTH CENTURY: CONSTABLE, MONET

A clear indication of the conflicts implicit in the notion of experimental painting can be found early in the nineteenth century in the life and work of John Constable. As is well-known, Constable concluded a lecture given at the Royal Institution, Albemarle Street, nine months before his death with the question:

Painting is a science, and should be pursued as an enquiry into the laws of nature. Why, then, may not landscape painting be considered as a branch of natural philosophy, of which pictures are but the experiments?

Even at this stage in his career, Constable poses the question, rather than asserting a dogma. Yet he had done much in the course of his life as a painter to justify the problematic attitude which he was putting forward. Reynolds had written: 'Study nature attentively, but always with [the Old] masters in your company.' Constable was ready, at least on certain occasions, to banish the Old masters from his company, and to admit such figures as the meteorologist and the chromatographer, who had never before been so close to the artist's side.

I refer of course to the various sequences of cloud studies which Constable attempted at certain points in his career. The striking feature of these works—or rather of the activity that produced them—was the fact that they were completed systematically, with direct reference to the scientific classification of meteorological phenomena. They were chiefly concerned with one particular locality, the 'natural observatory' of Hampstead Heath. And they were produced in fairly large quantities, the total from late summer 1822 alone amounting to around fifty. (1)

Evidence for the transformation of the artist's role implied in this activity is provided partly by Constable himself, and partly by the reminiscence of one of his acquaintances. On 23 October 1821 Constable wrote to his friend Fisher about his particular fondness for 'phenomena—or what the painters call *accidental Effects of Sky*'. He added: 'I hope you will not think . . . I am turned critic instead of painter.' The following related passage occurs in Trimmer's entertaining notes on the painter:

Later [in his career] he aimed exclusively at originality. There were a great number of oil sketches sold at his sale, done on the principle that there is no outline in Nature. These are full of truth and genius, and possess more variety than his pictures. That such productions did not find admirers was not the fault of the artist; but they required to be seen not simply with the eye, but by the mind.

Both these passages seem to bear, however obliquely, on the same curious dilemma. The decision to explore 'phenomena' requires a conscious shift in the artist's position, since close attention to accidental effects cannot be conciliated with the traditional precepts of his art. And, however unproblematic the new studies may seem, the public of the day must appreciate and respond to this shift in position on an intellectual level, since they cannot otherwise accept the investigation of 'phenomena' as a self-sufficient end of artistic activity.

The extent to which Constable's novel approach relied upon the scientist's example is a problem which can be answered on at least two levels. In the first place, Trimmer has spoken of his association with George Field, the author of a famous study of Chromatography. He suggests that Constable experimented with Field's specially prepared madders and ultramarine 'to give his clouds their characteristic purplish tinge'. A more original feature was his concern with the developing science of meteorology. Dr Kurt Badt has gone so far as to suggest that Constable's

original interest in 'phenomena' was provoked by his acquaintance with Luke Howard's *Climate of London,* which was appearing between 1818 and 1820.

It is perhaps worthwhile to draw together the various threads which have been traced, since, although the role of the experimental painter is by no means fully realized in Constable's career, its various constituents can be clearly singled out. The experimental approach involves an informed awareness of the branches of scientific knowledge which lie adjacent to the artist's own field, both as regards his medium and as regards the 'natural' or external phenomena which he is trying to record or recreate in the finished work. Here there is a parallel to be drawn with artists of the present day whose dedication to experiment involves them in problems of category not entirely dissimilar to those which beset Constable. Karl Gerstner writes of his kinetic *Tension picture* that it is an 'intellectual gimmick' to call this 'a work of art', when it is effectively 'a bit of nature'. 'Is everything taken care of, once again,' he asks, 'by the conventional criteria?' We can reply that, if the subsequent history of Constable's cloud studies is anything to go by, the conventional criteria do indeed extend quite considerably with the passage of time. Gerstner's interest in tension optics may come to seem as natural an exercise of the artist's choice as Constable's interest in meteorology.

If we return to the nineteenth century, we find very little evidence that Constable's novel approach was in any way developed or understood. Turner is recorded as having felt that the use of colour was not susceptible to scientific rules: hence he pronounced Field's *Chromatography* to be fallacious. Indeed the contrast between Constable's attitude to nature and that of Turner anticipates a distinction between experiment and what might be called 'venturesomeness' that I shall return to at a later stage. Constable recognized the element of risk involved in Turner's painterly forays when he spoke of him existing 'on a precipice.' And in condemning him at one stage for doing 'violence to all natural feelings', he was clearly establishing a distance between Turner's practise and his own, eminently natural course of exploration.

An exception to this neglect of the principles advanced by Constable must be made for the Impressionists, and for Monet in particular, whose career is analogous to that of Constable in several respects. In the words of Douglas Cooper, Monet's 'early phase from 1865 to 1871' gave place to a 'pure Impressionist phase' from 1872 to 1877, and this in turn yielded to 'an exploratory post-Impressionist phase from 1878 to 1891'. What Mr Cooper calls 'exploratory' is in many ways identical to our own criterion of the 'experimental'. In this third phase Monet is 'more consciously' painting pictures, and they are 'not pictures with different subjects but pictures with a single subject—light'. However, 'exploratory' is clearly a better word in this case, since Monet is in fact travelling throughout France and enduring con-

ditions of extreme physical discomfort in his desire to 'capture a specific effect'.

Monet's conscious departure from the traditional practise of the landscape painter therefore consists in two main features. He is indubitably concerned with 'phenomena' as such; indeed he is engaged in a protracted struggle with their limitless variety. 'Never three favourable days in succession,' he wrote to Geffroy in 1889, 'as a result of which I am obliged to make continual transformations, for everything is growing and getting green.' At the same time, and as a direct consequence, he is increasingly concerned not with the individual, definitive painting, but with the series that displays the same subject in a multitude of different guises. Groups of pictures such as his studies of Rouen Cathedral at various times of the day, and his famous *Haystacks* (2), were bound to imply new judgements upon the status of the individual work, and on his role as creator. Only by a voluntary or involuntary act of exclusion could one single out pictures from a series and view them in isolation. Attention was liable to be shifted away from the specific properties of individual works to the features which they held in common—and the conscious awareness of the artist's effort to match the indeterminacy of the atmosphere. No definitive solution to this quest could be imagined, and the artist was therefore bound to appear committed to a kind of 'open research'.

Constable and Monet therefore resemble one another in their commitment to the series, and to the open-ended activity which is implicit in this commitment. In the circumstances of their times, neither of them was willing or able to assume the new role which followed from the artist's decision to test his relationship to nature in this way. But they provide a significant precedent for the notion of 'experimental' art in the twentieth century. Indeed post-Impressionist painters such as Seurat and Signac, who are more widely known for their exploitation of scientific theory, are all the same much less interesting than Constable or Monet in this particular context. Seurat's study of Chevreul involved a thorough scientific analysis of the optical basis of colour constituents. But his application of the pointilliste doctrine did not imply any revaluation of the status of the individual work. Indeed he was pre-eminently devoted to the ideal of the unique, classical masterpiece.

THE MODERN MOVEMENT: CLASSICISM AND EXPERIMENT: MOHOLY-NAGY

As I suggested in my introduction, I do not think it permissible to group together all the activity of the Modern Movement under the title 'Experimental Art'. There is an obvious utility in referring to Kandinsky's musical analogies, Surrealist dream-pictures and the original Bauhaus building as 'experimental', to take a random

selection from the concluding chapter of Professor Gombrich's *Story of Art*. At the same time, it must be admitted that the very idea of experiment was antipathetic to the various theorists and practitioners of the constructive ideal whose example was dominant in the 1920s. Camilla Gray has referred to the period of Russian art between 1863 and 1922 as 'The Great Experiment'. Yet by the end of this period the notion of experimental art as an end in itself was widely condemned in Russia. The so-called 'laboratory art' of Malevich was dismissed as mere art for art's sake, while the 'production art' of Tatlin was held to be the true concomitant of the revolution in society.

This conflict was not merely a matter of political rivalry. The very existence of painting itself was bound up in the dispute over experiment, since this involved the central question of pictorial illusion. Troels Andersen has neatly brought out the sharp division between Malevich and Tatlin on this problem. He records that, in two 'alogical' paintings dating from 1914, Malevich incorporated a wooden spoon in accordance with the technique of collage. At a later date, however, he removed the spoon and 'simply painted it on the canvas'. Tatlin, on the other hand, envisaged his own use of collage as creating a 'material syntax': there was no question of any illusionistic portrayal since each object was fully and finally the expression of a particular *material*.

Tatlin was therefore concerned not so much with experiment as with the reduction of artistic principles to a rigid utilitarian formula. He aimed to achieve 'a modern Classicism', with the aid of materials that were 'comparable in their severity with the marble of antiquity'. And it is interesting to note that even Gabo, who utterly rejected the principles of 'production art', was equally convinced of the necessity to renounce the element of illusion in pictorial or two-dimensional art. He proclaimed in his 'Realistic Manifesto' of 1920:

Thence in painting we renounce colour as a pictorial element, colour is the idealized optical surface of objects; an exterior and superficial impression of them. . . . We affirm that the tone of a substance, i.e. its light-absorbing material body is its only pictorial reality.

There was a similar development in the position of Theo van Doesburg, with Mondrian the leading member of the Dutch De Stijl group. In an account of the modern movement in Holland, written for the English magazine *Ray* in 1927, Van Doesburg dismissed the architects of the Amsterdam 'Wendingen' group as 'the real *experimentalists*', adding the scathing comment that 'their "fantasy" knows no bounds'. If Van Doesburg was eager to disclaim the title of experimentalist, this was doubtless because he had established his own doctrine of 'Elementarism' three years earlier. The doctrine in question was devised precisely to combat 'fanciful and speculative procedure', and to replace it in all fields with an 'elemental means of formation' intended as the common property of all artists. For Van Doesburg, illusion of form was

merely a secondary or 'auxiliary' means for the painter, whose primary or 'elemental' means was 'form-time-colour'.

Further evidence for Van Doesburg's dismissal of experiment can be found in a fascinating note dating from 4 September 1930, which was published in *De Stijl* after his death in 1931:

Since people have not understood the true character of the canvas on the wall, they have believed that the suggestion of a plane in movement would give to painting a new dimension. The experimentalists (Lissitsky, Moholy-Nagy, Rodchenko, Eggeling, etc.) have materialised the plastic idea in the film, but, even if their experiments have a temporary value, they have gone back to the movement suggested in old painting, since the Greeks. In past painting of no matter what epoch, from Praxiteles to Delacroix, the artists have wished to suggest movement. This dynamism has found its summit in the Baroque with Michelangelo, to take the best example. This form of movement was none other than a sterilization of the instantaneous, of an action.

And here is the difference between new painting and old illusionism: the dynamism of previous times is replaced by constancy of relations, perfect equilibrium between action and repose.

Finally, let us add to this summary of Van Doesburg's views a short comment which he made in his manifesto of Concrete art, published in Paris in 1930:

The painting must be entirely constructed from purely plastic elements, that is to say, planes and colours. A pictorial element has no significance other than 'itself', in consequence the picture has no other significance than 'itself'.

This particular passage not only establishes Van Doesburg's connection with the views of the Russian Constructivists, but also anticipates a fundamental difference in attitude which persists to this day among painters who belong to the heritage of the Modern Movement. It is in particular those who have accepted Van Doesburg's designation of 'Concrete' artists who continue to maintain the anti-experimental attitude based upon acceptance of a vocabulary of basic forms having no other significance than themselves. Just as Van Doesburg condemns a dynamism based on 'old illusionism' and requires 'constancy of relations, perfect equilibrium', so Max Bill proclaims his allegiance to art as a 'non-changeable elementary truth,' and dismisses as 'serene play' the activity of contemporary kinetic artists. Richard Lohse, the other leading Concrete painter, follows up the connection between art and mathematics posited by Hélion in the manifesto of Concrete art, and suggests yet another argument against experiment:

The problems have moved, from the experimental stage to one of growing complexity and diversification. The difficulties in the development of serial and modular constructions lay in the necessity for method and product to be evolved at the same time. The complexity of the task demanded that method and result form a fundamental unit from the very outset. The difference between the lapidary and elementary working methods of early constructivism and the methods described here is

evident. While the geometrising or mathematising working basis under-
goes a variety of modifications in the course of the working process in
early constructivism, and the pictorial result is entirely different from
the starting basis, in the new construction the method and the picture
are inseparable.

Where Tatlin and Van Doesburg denied the relevance of experi-
ment by claiming that the work of art should be based on a
vocabulary of elemental forms having no ulterior, or illusionistic
significance, Lohse proceeds further in the same direction by
envisaging a creative process in which the 'method' and the picture
are one. In each case the aim is precisely to depart from the
flexibility, the 'open-ended' nature, of experimental procedure.
Presumably the artists of both generations would echo, with a
little variation, the dictum of Picasso: 'I do not search, I have
found.'

I should emphasize that this is only one tradition, if a major
tradition, in the Modern Movement. The painters whom Van
Doesburg branded as experimentalists must obviously be taken
into account in redressing the anti-experimental bias. In particular,
the career of Laszlo Moholy-Nagy, from around 1920 to his death
in 1946, provides perhaps an unequalled example of experimental
activity in the field of modern painting. It should be noted from
the start that the role of Moholy-Nagy as an experimental painter
was clearly bound up with an adhesion to that 'old illusionism'
which Van Doesburg had condemned. Perhaps this is partly
explained by the fact that the initial stimulus for his work came
not from the Constructivists but from Malevich. At any rate,
Moholy-Nagy's passionate interest in the transforming power of
light precluded him from accepting the notion of pictorial elements
with no other significance than 'themselves'. Even his wilder
projects were often conceived in terms of the traditional role of the
painter, as the following dialogue between himself and his wife,
Sibyl, testifies:

'I've always wanted to do just this—to project light and colour on clouds
or on curtains of falling water. People would respond to it with a new
excitement which is not aroused by two-dimensional paintings. Colour
would be plastic—'
'You've never stopped painting,' I said. 'You can't escape being a total
painter.'
'I know—but I didn't think anyone else knew.'

The simplest way of identifying Moholy-Nagy's attitude would
be to say that he was continually experimenting with new tech-
niques and new materials, but that he consistently employed these
materials and techniques to provoke and resolve plastic problems
that were implicit in the traditional pictorial space. Istvan
Kovacs has written in a perceptive article: 'Again and again
throughout his life he would turn to a new medium of expression
and would find in the new medium a new approach to an old
problem which he would then utilize in a previous medium.' As
an example, Kovacs instances an early photogram involving

transparent and translucent objects, from the basis of which Moholy arrived at 'the idea of experimenting with those objects by the mere utilization of pigments'. In other words, the problem which Moholy-Nagy set himself was that of recreating through traditional materials the complex light effects that are characteristic of photographic reproduction. *Schwarzes Kriesviertel* (4), which dates from 1921, is an example of this desire to simulate the overlapping of different layers of transparent material through the traditional medium of oil paint. Four years later, in *Konstruktivistisch* (5), the schematic texture of the etching is used to create a similar impression of overlapping planes close to the pictorial surface.

Moholy-Nagy was by no means content to rest at this highly accomplished demonstration of pictorial ambiguity through traditional means. He was eager to experiment with new materials, such as the glazed paper which serves as a background to water-colour and collage elements in his *Blaues Segment und rotes Kreuz*(6) of 1926. Once again, however, his ultimate concern was not with the exploitation of new materials as such, but with the purely aesthetic question of the pictorial surface. It was this proclivity which eventually caused his departure from the Bauhaus in 1928. As Otto Stolzer has written, 'his sphere was imprinted with the spirit of technology, but it was not itself technical. The artistic form was basic to him, the aesthetic concept always the most important point.' Obviously he could not remain in association with an institution whose new director, Hannes Meyer, was denouncing the original conception of an integrated education and stressing the need for specialized technical skills.

Moholy-Nagy's work at the Bauhaus had led him towards the possibility of mastering the medium of light through his three-dimensional 'Space-Light Modulator'. But his move to London in 1935, which offered him the chance of experimentation with new plastic materials in his work for Korda's *The Shape of Things to Come*, was accompanied by a revival of interest in the possibilities of the pictorial surface. From Autumn 1936, Sibyl Moholy-Nagy tells us, he never interrupted his painting again, and his efforts were increasingly devoted to the solution of one enormous problem: 'For ten years . . . he thought, felt, saw, and painted three-dimensionality.' His *Kupferbild* (3), a work in oil on engraved copper which dates from 1937, already displays the remarkable subtlety of his investigation into this central theme. Perhaps the peak was reached in his series of 'space-modulators', such as the *Vision in Motion* (1940) of which Istvan Kovacs has written:

To accentuate the duality of frontal image and back shadow the artist maintains the format of the transparent plastic sheet held out from a background, but instead of placing his figure on the plastic sheet he cuts out two large holes in the plastic and fastens to the background two similar figures. The joke is that although both the format of the space modulator and the duality of the figures—one light, the other dark— remain, the duality is not caused by the play of light on the plastic.

B

This kind of 'intellectual game' with the interplay of transparent and opaque materials recalls the conscious exploitation of perceptual and semantic ambiguity in some of Duchamp's work, which will enter this account at a later stage. But in Moholy-Nagy's case, the game can only be called intellectual in the sense that we exercise our perceptual faculty and our mind simultaneously upon the bewildering interplay of elements. The ultimate sense of the work is plastic rather than conceptual.

With this reference to the role of the spectator, we reach a question which applies not simply to Moholy-Nagy, but to the whole notion of experimental activity in the arts. Moholy-Nagy himself was fully aware that the notion of the work as experiment necessarily implied the exhibition at which the successive experiments could be rehearsed in front of the public. As implied in the passage already quoted in my introduction, this was in large part an aid to the painter's own self-knowledge: 'There is nothing more important to me than seeing my whole development in retrospect.' But the exhibition was also an invitation to the public to share in the artist's process of discovery. As Moholy-Nagy wrote in 1934, 'the real purpose of exhibiting my pictures is to make the spectator grow slowly as I grew in painting them. What a long way to go!'

THE POST-WAR PERIOD: RESEARCH AND THE GROUPS

My summary consideration of Constable and Monet brought into relief two complementary aspects of experimental painting. The painter's procedure could be viewed as an experimental *process*, involving a departure from the artist's traditional role and a shift away from the notion of the individual masterpiece as the end of artistic endeavour. At the same time, the work itself could be regarded as an individual experiment, in the sense that unprecedented resources of technique were being used to 'capture' the fleeting quality of natural phenomena. With Moholy-Nagy, there is a radical departure from these presuppositions. The natural world is no longer the given quantity against which the painter must assert his skill: indeed Moholy-Nagy seems to have wished to follow in the most literal terms Gabo's judgement that the artist creates images 'on to nature' rather than of nature. In effect the problem becomes one of finding new solutions to old problems: the 'subject' of the work is none other than the traditional pictorial space. And Moholy-Nagy justifies this procedure not in terms of the end achieved, whatever that might be, but on the grounds that his successive works provide 'a continuous picture of how the relationship of pigment and light, and of line and space, developed'.

If we turn our attention to the post-war scene in Europe, it is clear that the dominant experimental tradition in the plastic arts bears many resemblances to the practise of Moholy-Nagy.

This is particularly true of the so-called 'New Tendency', a wide-spread movement among younger artists which began to crystallize towards the end of the 1950s and provided, as Jack Burnham puts it, 'a reasonable aesthetic alternative to . . . both Constructivism and later Object Art'. The aesthetic of the New Tendency diverged from the Concrete tradition in its absolute rejection of what Max Bill called 'non-changeable elementary truth'. At the same time, it did not involve the complete abandonment of aesthetic categories for utilitarian ends which had been anticipated in Tatlin's Productivism, and to some extent fulfilled in the last years of the Bauhaus.

In more ways than one, the stance between the immutable and the utilitarian which allowed the New Tendency to safeguard both the autonomy of the plastic arts and the notion of experiment was close to that evolved by Moholy-Nagy. 'Man may "test" the organization of perceivable reality', wrote an Italian critic in the catalogue of a New Tendency exhibition which took place in 1964. If this formulation recalls the quest of Constable and Monet, a passage from Bruno Munari, one of the most notable theorists of the movement, reminds us that this reality has its focus in the work itself and not in any ulterior field, just as it has with Moholy-Nagy. The work is to be 'a sphere in which events may take place, an area of a previously unknown world of creation, an aspect of a new reality to be observed through all its variations'.

What is brought to a final conclusion in the work of the New Tendency, and particularly in that of such prominent members as the Groupe de Recherche d'Art Visuel, is the theory of the artist's activity as a process, which must be viewed as such, and not in terms of the individual works which it gives rise to. The Groupe de Recherche d'Art Visuel determined in common to 'overcome the traditional image of the uniquely inspired painter of undying masterpieces'. Instead they envisaged a gradual accumulation of aesthetic knowledge:

they will start from their individual artistic activities and, through a programme of research organized and sustained by their communal examination of the work, ideas and plastic activities of each member, will build up, little by little, a firm basis (both theoretical and practical) of communal experience.

In addition to this feature, the Groupe de Recherche d'Art Visuel were ready to provide several reasons why the visible results of this process of research should be of interest, or even of value, to the spectator. Where Moholy-Nagy had spoken of the 'growth' of the spectator which was to take place in response to the growth of the artist, the Groupe explained:

The work is not therefore presented as a foil to his admiration, it is simply that it provokes his intervention. This interaction can either make him responsible for the phenomenon created, or develop his faculties of perception and awaken his interest in new phenomena. . . . In

certain cases it will be no more than a form of play; but in others it will disturb a whole system of education, or even a way of thinking or a routine of behaviour.

In several respects, therefore, the theory and practise of the New Tendency extends that which was developed on an individual level by Moholy-Nagy. But the differences between the two are perhaps as important as the resemblances. In the first place, the tenuous balance between surface and space—the domain of pictorial illusion—no longer holds the supreme value which it held for a genuine painter like Moholy-Nagy. Bruno Munari recalls Gabo and Van Doesburg when he writes: 'Clearly, then, a work of programmed art is not to be viewed and considered as an object representing something else, but as itself the "thing" to be viewed and considered.' This may seem a curious judgement, since the pioneers of the Modern Movement who anticipated it were for the most part working with simple forms, colours and materials, whereas the artists of the New Tendency appear to be using complex factors such as transparency and actual motion which can only result in illusion. But the nub of the question is not so much the problem of illusion as the whole issue of pictorial representation in which illusion occupies a subsidiary place.

What has in effect occurred as a result of the New Tendency is a withering away of the whole notion of the work of art, in response to the pressure of such concepts as research and group activity. As Munari's equivocal reference to the 'thing' implies, the work which is purely experimental, entirely open, becomes unclassifiable. In his own terms, it becomes clear that 'not all visual art need necessarily take the form of painting or sculpture'. The principle upon which an 'individual creative intuition' is conveyed is simply that of being adequate to satisfy 'the basic rule of good design in having its most natural form'.

The difference between the two approaches could therefore be expressed in these terms. Moholy-Nagy's experiment is still directed towards the solution of pictorial problems. The works which he produces still belong to the genre of painting, and offer his own characteristic solutions to problems which have always been implicit in the notion of pictorial representation. With the artists of the New Tendency, on the other hand, the 'form' which the creator has chosen is the most appropriate solution to a problem of applied design. It may turn out to be a rectangular surface with two-dimensional emphasis, but it is not for that reason to be thought of in terms of the genre of painting. Even a highly accomplished display of spatial ambiguity, such as Martha Boto's *Labyrinthe au Carré* (7), belongs to the rectangular format only as a matter of convenience. Its very homogeneity seems to deaden the implied pictorial plane, if we choose to view the work in those terms.

It is obviously an issue of great importance in this study that the categories of painting and of experiment should have so diverged in contemporary art that it seems no longer accurate to

speak of experimental paintings, in the sense in which many of Moholy-Nagy's works answered to this description. It may indeed be a feature shared only by the first generation of 'abstract' painters that they could preserve the sense of pictorial space while developing a potentially autonomous vocabulary of forms.

This would, however, be an extreme conclusion, and one that is only justified in relation to the particular tradition which we have been considering. While it seems fair to maintain that the experimental approach represented by Moholy-Nagy and the Groupe de Recherche d'Art Visuel constitutes the purest example of this type of artistic procedure, it is also amply clear that its logical conclusion is the tyranny of experiment over genre, of procedure over product. The major part of this study will therefore be devoted not to this tradition, but to a type of experiment which is impure in the sense that it is dominated by a characteristic tone, or directed into a particular channel. Where Moholy-Nagy conducted an investigation into the most general, the most basic pictorial problems, and the artists of the New Tendency elevate the activity of optical research to an absolute status, a large number of contemporary artists begin with a specific type of pictorial problem and pursue it in accordance with a particular intellectual or emotional attitude rather than in a spirit of scientific detachment. These artists could therefore be said to occupy a half-way point between the traditional painter and the wholly experimental one. Many of their presuppositions are traditional, or can be related to traditional values, but their work is nonetheless directed by a positive principle or *dynamic* which drives them beyond their original positions.

Clearly this direction or dynamic is intimately related to what is usually termed the style of a particular painter or group of painters. Clearly it is also related to the broad division into movements which is accepted for the classification of much contemporary art. At the same time, this correspondence is by no means obvious in every case. Two of the dynamics which I have chosen to explore, those of Construction and Abstraction, relate to the tradition of Constructivism, De Stijl and the Bauhaus. Yet the distinction between the two concepts to some extent cuts across the divisions which are usually accepted in this field. In the same way, my categories of Destruction and Reduction bear a clear relation to the tradition of Dada and Surrealism. But while the latter can be traced almost directly to the work of Marcel Duchamp, the former requires reference to certain aspects of French nineteenth-century painting.

A final point must be made about these four paths which will be traced in the next sections. Mention has been made, in the case of Monet and Constable as well as that of Moholy-Nagy, of the experimental painter as a man engaged in an 'open' type of research, which cannot by its very nature result in definitive solutions. This would apply also to the commitment to 'continual research' undertaken by many members of the New Tendency. But a path

of investigation which is not so neutral—which is labelled 'Destruction' or 'Reduction'—clearly affords some possibility of reaching a definitive result. Both these procedures suggest a terminal point—the final destruction or reduction—which may be embodied in a type of work. And yet this final point need not lie within the field of painting which is our main concern. It is not difficult to see that the path of construction, for example, tends naturally to architectural form. Indeed all these directions arguably tend towards a final state which is not exclusively pictorial, and thus my account can only be complete with the aid of certain references which lie outside the immediate area of my subject.

2 Paths of experiment: construction

Mention was made in the last chapter of the deep division between Malevich's use of illusion and Tatlin's 'material syntax'. Tatlin is making a radical departure from tradition in his insistence that the various materials combined in his reliefs have no area of reference beyond their own specific physical qualities. And his example has been adopted by many more recent artists in the constructive tradition, who prefer to view their works exclusively, or at least predominantly, on the syntactical level. But there is a small minority of artists in this tradition who attempt to direct their activity and define their work in terms which go beyond the level of syntax, and can be related in effect to the aims of the traditional painter. These artists, who accept the principle of construction while retaining in some form the representation of nature, deserve to be considered here.

It should be emphasized at the outset, however, that this 'representation' of nature is closely allied to the constructive aims of these artists, and not merely a superficial aspect of the works in question. Jack Burnham has drawn attention to an amusing contrast between two statements made by the American sculptor George Rickey. In 1956 he was prepared to state: 'Imitation of nature would be so difficult in my metier and look so awful . . . that I am spared the whole question,' In 1963, however, he modified this view: 'The artist finds waiting for him, as subject, not the trees, not the flowers, not the landscape, but the *waving* of the branches and the *trembling* of stems, the piling up or scudding of clouds, the rising and setting and waxing and waning of heavenly bodies. . . .' This adoption of certain characteristic forms of natural motion, which is entirely appropriate for the kinetic artist, can scarcely be described as a process of representation. For one thing, the analogy traced between the motion of the art work and the motion of some natural feature is by no means a stable one: variation in the former can lead the spectator to invoke some entirely new area of suggestion.

But if the artists whom I shall consider posit some essential, unchanging relationship between their works and the world of nature, it would be wrong to imagine that their approach is not problematic. In fact there are such considerable problems involved in the whole notion of imitation or representation of nature that the question must be considered on as broad a scale as possible.

First of all, it is perhaps necessary to point out the comparative novelty of the idea of 'realistic' representation of nature. Realism is by no means to be equated with illusionism, since the latter presumes the natural object to be the final end of the painter's perception of the world, while the former allows the possibility of some transcendent level of being. The distinction is made clear by the following passage from Petronius' *Satyricon*:

I entered a gallery hung with wonderful paintings of every kind. I saw works from Zeuxis' hand as yet undimmed by the ravages of time, and I considered, not without a certain thrill of respect, some cartoons by Protagoras, more like reality than Nature herself. Then I came to work by Apelles which the Greeks call monochromes, and really worshipped them. For the contours of his figures were rounded off to a life likeness with such dexterity that you would have thought them pictures of their souls as well.

In this passage the painter is clearly seen as one who has transcended the limits of everyday appearance and penetrated to a level of superior reality. We may juxtapose with it a very different passage from the eighteenth-century *philosophe* and art critic Diderot, in which the painter's conventional methods, and not his magical powers of penetration, are brought under consideration. As Diderot puts it, 'the sun of art being different from the sun of nature; the flesh of the palette different from my own; the eye of one artist different from that of another; how could there not be an element of *manner* in colour?'

Leaving aside the widely differing contexts of these two passages, one can extract two antithetical views of the artist's relationship to nature. In the first case, his illusionistic method enables him to suggest a degree of reality superior to natural appearances. In the second, he is to be concerned with establishing a kind of equilibrium between the world of nature and the representational methods available to him: his solution is bound to be a compromise, or, in other words, it testifies as much to his individual 'manner' as to the forms of the external world.

On the surface, these two views might appear to be quite incompatible. But in fact the tendency which I shall be tracing in this section amounts to a reconciliation of the two. The invention of photography demonstrated to the artists of the late nineteenth century that the supposedly 'realistic' portrayal of objects was simply one mode among many others: hence the ideal of penetrating reality, rather than stopping at the irreducible object, became a reasonable aim once again. At the same time, the practise of Cézanne and the doctrine of the Synthetists reinvigorated Diderot's theme: what Maurice Denis called 'the symbolism of equivalents' involved the creation of a vocabulary of forms that had their basis in the painter's distinctive methods and yet were adapted to 'representing' the external world. It is in the particular case of Cézanne that the two ideals are united. For, in his work, the perception of the external world in terms of sphere, cube and cone is not simply an indication of 'manner', but a way of penetrating the innermost structure of the natural world. (14)

CONSTRUCTIVE VISIONS OF NATURE: SCHWITTERS, LISSITSKY, HELION

Despite the example of Cézanne, the attempt to evolve a geometrical vocabulary which was at the same time an instrument

for penetrating natural appearances did not materialize until the Modern Movement was well under way. Only when the constructive idea had undergone a certain amount of autonomous development was there any concern with redressing the balance. Thus by 1927 Kurt Schwitters was able to make the following clear statement about the new vision of nature:

The imitative picture formerly differed considerably from the surrounding world: it was essentially a pale imitation, whereas the new naturalistic work of art grows as nature itself, that is to say, it is more internally related to nature than an imitation possibly could be. I refer here to the publication NASCI which I composed with Lissitsky. There you will see clearly demonstrated the essential likeness of a drawing by Lissitsky to a crystal, of a high building by Mies van der Rohe to the austere construction of an upper thighbone; you will recognize the constructive tendency of the position of leaves to the stem . . .

The publication to which Schwitters refers is the double number of *Merz*, dating from three years earlier, which he edited in conjunction with Lissitsky. The front page of this edition bore a prominent dictionary definition of the word Nature, which was shown to derive 'from the Latin NASCI, that is to become or come into being, that is everything which through its own force develops, forms or moves'. Of the illustrations which Schwitters mentions, the photographs of the thighbone and the block of flats in juxtaposition are particularly effective. They bear the caption: 'We know no problems of form—only problems of construction. Form is not the goal, but rather the result of our work.'

Schwitters himself appears to have made little attempt to follow up the implications of the NASCI programme, in theory or in practise. But Lissitsky was ready to extend and develop it. In 1925, the year after he had contributed his manifesto to *Merz*, he wrote a long article entitled 'A. and Pangeometry' for the *Europa-Almanach*. There is a clear continuity between the arguments advanced in these two pieces.

In his manifesto for *Merz*, Lissitsky insisted first of all on the artistic significance of the machine, which was no longer to be thought of as the enemy of nature. 'The machine has not separated us from nature,' he claimed, 'through it we have discovered a new nature never before surmised.' The work of art was not to be thought of as a static portrayal of a static scene, but as 'a stopping-place on the road of becoming and not the fixed goal'. As a result of this capacity for reflecting and indeed recreating the dynamic processes of nature, the work constituted 'not a system for acquiring cognition of nature', but 'a limb of nature and as much . . . an object of cognition'.

Lissitsky's article for the *Europa-Almanach* reiterates the principle that it is through dynamic means that the new vision will be realized. He follows the painter's relationship to nature through several historical stages, touching upon 'planimetric space', in which the objects are arranged along a flat two-dimensional plane, and 'perspective space', which, he holds, persisted

right up to the date of Malevich's first square. His final goal of 'imaginary space' does not permit such a division between form and content, since it is entirely the creation of a process in time:

we know that a material point can form a line; for example: a glowing coal while moving leaves the impression of a luminous line. The movement of a material line produces the impression of an area and of a body. There you have but an intimation of how one can build a material object by means of elementary bodies, in such a way that while it is motionless it forms a unity in our three-dimensional space, and when set in motion it generates an entirely new object, that is to say, a new expression of space.

Lissitsky therefore reaches a position which allies him to Moholy-Nagy. Both share the goal of an 'a-material materiality', a specifically modern solution to the problem of pictorial illusion. But in seizing upon the notion of the work of art as process, and as such the partner of natural objects 'on the road of becoming', Lissitsky has somewhat impoverished his original notion of direct formal analogy between the work of art and the work of nature. Schwitters' suggestive remarks about 'the essential likeness of a drawing by Lissitsky to a crystal', and 'the constructive tendency of the position of leaves to the stem', are hardly borne out in practise.

The theme which we have been tracing therefore disappears in the late 1920s. It might plausibly be claimed that Lissitsky's vindication of the work of art as a 'limb of nature' was a way of asserting the freedom of the work from any kind of parallelism with nature. The assertion that the work was already within the natural world dispensed the artist from defining his position in relation to it. Yet there is at least one more example, from a painter within the constructive tradition, of the attempt to define a new relationship between the artist and the world of nature, while remaining securely within the post-Cubist vocabulary of geometrical form. This comes from the French painter Hélion, who was a founder-member of Van Doesburg's *Art Concret* group in 1930. Hélion claimed in 1936, in an article for the English magazine *Axis*, that 'the painter has to go everywhere at once, as nature does. This miracle is possible in a picture, that the eyes face, contain, where all the world space is summed up, where all degrees are possible.' Subsequent passages in his article hark back to *Nasci*:

The chief point is to work within the meaning of nature instead of the appearance . . . The tree, coming from a germ-point goes toward light, multiplies its directions into space, each of them into thousands of hands . . . Birds, going from one point to another and coming back, embracing space, measuring it, rhythmically dividing it and discovering a speed in its modulations.

Hélion's fascinating article is however no more than a parenthesis in the history of painting in the 1930s. And its challenging propositions are hardly reflected in the paintings he was producing

then. Perhaps the climate of this decade, when the dichotomy between Surrealism and the Abstract/Concrete replaced the very wide stylistic spectrum of the 1920s, was particularly inimical to the development of a mode which appeared to cut across accepted boundaries. It was only in the next decade, when the American artist Charles Biederman achieved his own distinctive pictorial synthesis, that constructive method was finally yoked to a new vision of nature.

CHARLES BIEDERMAN: THE STRUCTURIST VISION OF NATURE

Before I start to investigate Biederman's theory and practise as an artist, one salient point must be clarified. In my opening section, painting was defined essentially in terms of the plane surface. Yet Biederman's work belongs to the category usually identified by the title 'relief': that is to say, it involves three-dimensional projections from a two-dimensional surface. I have no intention of suggesting that the relief, which enters modern art with Tatlin around 1914 and today forms part of the vocabulary of a wide variety of artists, is to be accepted as a particular genre of experimental painting. On the contrary, my earlier references to Tatlin indicate that he decisively cut all links between his own work and the traditional pictorial modes. Those contemporary artists who work chiefly in relief have in the main followed his precedent. However there does exist, within the overall field, a direction which can still be related to traditional painting. Charles Biederman, who was at the same time the first artist to adopt relief as his exclusive medium, is the most distinguished representative of this direction.

Biederman himself has effectively posed the problem which arises in an article entitled 'Symmetry: Nature and the Plane', which was first published in 1960. He describes the evolution of his particular type of relief in the following terms. 'What is required, then, is that the rectangle of the canvas become an actual non-illusionistic plane from which actual planes gradually emerge into the full reality of structure.' But Biederman is quick to emphasize that the presence of these 'non-illusionistic planes' is definitely not the sign of a genuinely three-dimensional art—'a new sculpture'. On the contrary, the new artefact demands to be seen in terms of the 'development *from painting to relief*'.

Biederman's work may therefore be legitimately treated within the context of experimental painting since it is conceived as a direct extension of the picture plane. What is more, it is an extension forced upon the painter by the continual evolution of our vision of the external world. Biederman does not consider that he has in any way abandoned 'nature'. Indeed he holds that it is only by 'evolving into the *structural dimensions of nature's reality*' that the artist can overcome 'the impasse of painting'. Despite the fact that the planes in relief are 'non-illusionistic', they have

not lost their representational quality. The work exists both on a structural level and in its relationship to the natural world, even though that relationship may be very far removed from the traditional one.

The development of Biederman as an artist can be seen from two different angles, which reflect this division between structural logic and wider implication. His book, *Art as the Evolution of Visual Knowledge*, shows the relief as the end product of a long sequence of pictorial forms. At the same time, it cannot be irrelevant to consider his works individually, as the record of a particular response to nature—no less valid in his terms than the photographic mode which rendered the traditional vision of nature obsolete. These two aspects are, of course, complementary. But it is more convenient to study them in turn.

For Biederman the central dilemma of modern painting was initially presented, and to a remarkable extent resolved, in the careers of Monet and Cézanne. The status of Monet is somewhat ambivalent, since he is held to have provided the 'action-tachistes' of the post-war period with an excuse for 'dissolving the *surface* perception of nature' and 'flaying the canvas at random'. Cézanne, on the other hand, was able to recognize from the start that Monet was in fact attempting to articulate a new 'view of reality'. And he himself was able to extend Monet's interpretation of the world as 'color-structure' into his own articulate system of 'spatial-color-structure'.

The implicit message of this reading of the past is that, while Monet was able to elaborate his vision exclusively in terms of the pictorial surface, Cézanne was bound to extend his pictorial field into a spatial dimension. 'Nature is not on the surface,' he wrote, 'but in the depth.' Biederman quotes this statement with approval, but shows that Cézanne's preoccupation with planes led inevitably to the 'planism' of Mondrian, in which the spatial plane reached a pitch of pure creation, but lost all contact with the natural world in the process.

This is clearly a crucial stage in Biederman's argument. In his own terms there was now a choice between 'Cubism as a construction towards a new reality of nature', and an art which was condemned to concentrate upon the 'destruction' of the old reality. All the Cubists opted for the latter course, and Mondrian himself soon 'lost all coherent contact with nature'. Biederman does not mention the passages from Schwitters and Lissitsky with which this chapter began. But his solution to the problem of conciliating constructive method and reference to nature is in certain ways close to theirs, at least on the theoretical level. He recommends neither the capitulation to sensory impressions implicit in the later work of Monet, nor the 'superior' pose of the tachiste, but a happy medium: 'The artist is simply "parallel" to nature.' Just as the photographer can reveal through his distinctive medium aspects of the 'structural diversity' of nature that had never revealed themselves previously, so the maker of 'structurist' reliefs is able to

achieve a 'new nature vision', which can be defined as the revelation of 'events taking place in the spatial poetry of light'. It is symptomatic of Biederman's genuine belief in the complementarity of the photographic and the structurist vision that he should have accompanied his 'Art Credo', published in *Poor. Old. Tired. Horse.*, with two superb photographs of dense woodland growth.

We can hardly proceed further into Biederman's new interpretation of nature without reference to the works themselves. But perhaps we may approach them indirectly by way of a parallel not employed by Biederman, which is however consistent with his attitude to the development of modern painting. He states that he regards 'the great works of Courbet' as the last wholly successful examples of mimetic or imitative painting. A possible explanation for their success might be the fact that their mimetic quality is stressed on the purely material level. In a work like *La ronde enfantine*, the green pigment has a materiality—a kind of vegetable density—that seems ideally attuned to the representation of woodland and undergrowth. It is not simply that leaf and tree are recognizable as objects, but that their 'translation' into material terms lends an added quality of 'realism' to the work as a whole. (59)

A more or less similar process occurs when we look at Biederman's finest reliefs. There is no recognizable naturalistic scheme involved, but the colours have such density, such power of natural suggestion, that they seem to act as 'carriers' for a specifically natural vision of the external world. The various planes which emerge from the surface of the relief are not perceived simply as 'non-illusionistic' objects. On the contrary, they dissolve into the overall pictorial scheme, serving as structural boundaries to the complex space which is created by their emanation of light.

While Biederman's work is obviously not unique in this respect, it can none the less be distinguished from that of other artists who use similar effects. Victor Pasmore, for example, could certainly be said to employ colours that have a high degree of natural suggestion: his *Hanging construction in white, black, maroon, green and pink* is a relevant instance (11). But if there is a type of representational scheme which corresponds to Pasmore's distribution of colour and material, it is the almost Whistlerian Impressionism of his early paintings, where accents of colour stand out against luminous grey and green haze. One might say that Pasmore's colour accents are episodic, both in his paintings and in his reliefs. Those of Biederman, on the other hand, are constructive: they 'make form' within the pictorial space.

Clearly the nub of Biederman's pictorial method lies in his rejection of episodic colour, and of the atmospheric space which it relates to, in favour of this constructed space, where the relationships between elements in relief resolve themselves into a coherent vision of 'spatial-color-structure'. However there may still be some ambiguity in my account between Biederman's aim, expressed in these terms, and that of other artists working in

relief. A comparison between the aims of Biederman and those of the English artist Anthony Hill may help to remove this ambiguity.

Anthony Hill rejects from the outset any notion that his reliefs can be related to the natural world. He condemns for example, the critic who equates the repeated angular forms in some of his recent work with the wings of a flock of birds in flight. But this is a comparatively trivial association. His attitude to Biederman's doctrines is more circumspect, as can be seen from the article on 'Constructions, Nature and Structure', which he published in 1959. At this point he was in effect replying to a query from Biederman as to why he chose to accept certain limitations of space and vocabulary if he was not abstracting from the structural process level of nature.

Anthony Hill's answer was that any 'purely invented abstract artefact' could be regarded on one level as a piece of 'pure architecture'. But there were, in addition, 'other intentions'. 'Every construction presents a thematic and is likely to embody particular intentions—the artist's credo.' The issue therefore had to be narrowed down to a consideration of particular works, and groups of works, by a particular artist, in relation to his publicly expressed intentions.

If we follow Hill's advice, and compare works by the two artists in the light of their respective intentions, the differences are quite obvious. In both cases, the works can be reduced to the condition of 'architecture': in other words, they can be viewed on a purely syntactic level. But Hill's expressed intentions relate directly to this syntactic level, since he is deeply concerned with the numerical and geometrical relations between the elements displayed on the surface. Biederman's intentions, on the other hand, are expressed in relation to 'nature', in other words to a complex system existing over and beyond the network of relations on the pictorial surface. While Hill approaches Tatlin's concept of a 'material syntax', with his undisguised use of materials, Biederman negates the specific material properties of his structural elements by the use of applied colour.

There is really no difficulty in accepting the principle of distinction which Hill's article suggests. While every work, like every meaningful structure, must embody a syntactic and systemic level, it is quite clear that some works lean more heavily on one level than the other. While the mathematical rigour and the undisguised materiality of a relief by Hill concentrate attention on the syntactic level, the grouping of elements and the application of colour in a work by Biederman evoke not merely a literal space, the space of the work itself, but a space 'beyond'. It may seem unsatisfactory if we are inclined to interpret this beyond as the space of the natural world only through the intermediary of paintings by Cézanne that seem to echo Biederman's structures from a different degree of focus. But this would not trouble Biederman, whose belief in the 'evolution of vision' implies a

reciprocal influence between our modes of seeing and the painter's vision of the external world.

We have considered Biederman's work in the historical setting which he himself has prescribed and in the relationship to nature which distinguishes it from the great majority of other types of relief. A few words remain to be said about his procedure as an artist, and the extent to which this has followed a comprehensible path of development. Although Biederman originally began to work in a constructive manner as a result of stimulus of De Stijl and Constructivism, he claims to have thrown off this initial influence by 1947. Thereafter his evolution as a painter has been, in principle, systematic. In 1951-2, he even constructed a series of 'Teaching Models' (9, 10), which were designed to show the development of his work from the cube to the spatial plane. He advised young artists not to follow the course of his previous enquiries, but to begin with the systematic extension of the basic pictorial language represented by these models. Another piece of evidence for his conception of the artist's career as a systematic enquiry into spatial problems is provided by his habit of giving his reliefs no title other than a number in a series. A comparison between works from various stages of his development shows that there is the closest connexion between his progressive conquest of pictorial space and the transformations in his vocabulary of basic forms. The subtle and unified spaces of his most recent works depend radically on the decision to use angular as well as orthogonal relationships between the plane surface and the elements in relief. (8, 12, 13)

Yet there is an element of paradox in the way in which Biederman has proceeded—in the sense that his formal development of a geometrical vocabulary has brought him closer and closer to the traditional pictorial space. While the use of constructive methods has in general led artists away from traditional modes to architectural and environmental schemes, it has led Biederman to what is in effect a revaluation of the easel picture. Both in their scale and in their spatial values, Biederman's recent reliefs offer the same tranquil relationship to the spectator as their pictorial predecessors did in the nineteenth century. There is no obtrusive manner—nor is there breath-taking illusion. 'The artist is simply "parallel" to nature.'

JOOST BALJEU: THE SYNTHESIST VISION OF NATURE

If Biederman's work remains within the proportions of the traditional easel picture, the Dutch artist Joost Baljeu shows how the constructive principle can be extended from relief to sculpture, and finally to an architectural scale. Yet Baljeu is no less dedicated than Biederman himself to an artistic procedure which remains 'parallel' to nature.

Baljeu's theories have been expounded with great clarity in the

various contributions which he published in his own magazine *Structure*, and in the booklet *Attempt at a theory of synthesist plastic expression*, which appeared in 1963. His view of the distinctive relationship of the 'synthesist' artist to nature is well conveyed in the following passage from his article, 'Nature and Art since the Second World War':

For the classical artist a tree was composed of a massive cylindrical stem on top of which the leaves appeared as a massive cone or sphere. In his technique he expressed this by means of perspective and by using shades of each colour to qualify mass. The Synthesist artist however perceives a tree as consisting of vertical and horizontal elements (stem and branches) with a large number of planes in between (the leaves) in several spatial positions. Regarded from several points of view the round and massive quality of the tree's basic forms (cylinder, cone or sphere) is perceived in its plane-linear aspects: the tree is seen as a constructive pattern in nature, as a process of growth.

In this passage Baljeu shows clear affinities to Cézanne and Biederman. But there are significant differences in the works themselves. It would clearly be absurd to describe Biederman's reliefs as specific portrayals of nature, in the same sense that Cézanne's paintings refer to a specific natural scene. At the same time, Biederman's works are undoubtedly *particularized*: they each possess a strong individuality in spite of the fact that their formal vocabulary is held in common. With Baljeu, on the other hand, the successive works are more obviously *generalized*. It is relevant to note that, while Biederman allows himself an exceptionally wide colour range, Baljeu confines himself to standard coloured materials which recall the Neoplasticist range of primary colours.

This difference in the use of materials points to a significant divergence in attitudes to the natural world. Baljeu actually condemns the practice of 'copying structural forms in nature', which he associates with the Constructivists, and recommends for the artist 'an inner process of translation, which can often take considerable time'. This process inevitably calls to mind the doctrine of Neoplasticism, which Baljeu himself has described as 'the outcome of a long process of translating naturalistic shapes towards their structural relationships'. But Baljeu differs from Mondrian and Van Doesburg in the important respect that his formal vocabulary is never allowed to develop on purely autonomous lines. In the very first issue of *De Stijl*, Mondrian proclaimed that 'cultivated man of today is gradually turning away from natural things'. For Baljeu, on the other hand, the artist must move into a direct relationship with nature: 'the Synthesist artist regularly checks his work against natural appearances.'

At this point it becomes clear where the fundamental difference between constructive and abstractive procedure lies. Biederman may work with a very wide degree of variation within his vocabulary of formal constants, where Baljeu tends more readily towards the creation of definitive formal schemes. In both cases

however, the process of 'translation' from the natural world is one that cannot be performed once and for all at a certain stage of the artist's career. The contrast with so essentially 'abstract' a painter as Vasarely will become obvious in the course of the ensuing chapter.

The meaning which Baljeu attaches to this regular reference to nature can be demonstrated most successfully in the case of his *Construction W XI* (15). This was fully analysed in the *Attempt at a theory*, where Baljeu's objection to the 'copying' of structural forms is explained. The essential principle which he discerns beyond all natural formation is that of the 'rect', or straight line. Photographs of electric sparks, splashing milk, a leaf and a section of bone illustrate the point. From a basis which is for this reason essentially orthogonal, he sets out to encompass the 'three basic formative principles in nature', which are 'straightness, obliquity, roundness'. *Straightness* is easily achieved, through the pervasive orthogonal relationships. *Obliquity* arises, in the *Construction* as in his other works, from the displacement caused by overlapping surfaces that project from the plane surface. Finally, *roundness* is conveyed by a global view of the entire composition, which can be divided into one central circular area and two symmetrically opposed eccentric circles.

Baljeu's constructive path leads him, as I have suggested, from the relief to the free-standing construction, and from the construction to the architectural project. In the exhibition of his work which took place at the Stedelijk Museum in spring 1969, the eleven works exhibited were all entitled 'Synthesist constructions' (15–18). But the last in date, labeled *A III*, was clearly 'architectonic', even though Baljeu disclaimed the intention of planning a formal work of architecture. The distinction between this 'architectonic landscape . . . in micro-scale' and conventional modern architecture signifies once again his rejection of the abstract and his concern for a regular relationship to nature. Indeed the planning of man's whole environment in Synthesist terms consists precisely in this achievement of a reciprocal relationship, with the man-made building no longer radically separate from its surroundings:

In the plastic city of space-time nature will no longer be a separate part called 'park'. Nature interpenetrates the city just as the city encroaches on nature, together creating one large whole possessing various centres of greater and lesser activity.

C

3 Paths of experiment: abstraction

As we have seen in the last chapter, the constructive artist adopts a stance 'parallel' to nature. The very conditions of his constructive method keep him from imitation: yet his method does not involve a divergence from the natural world. On the contrary, he 'regularly checks his work against natural appearances'. And, for Baljeu at any rate, the final goal of this activity is an 'interpenetration' between the natural and the constructed world.

This constructive attitude should not be seen in isolation. In effect it is one of three typical views of the relationship between art and nature, the remaining two of which can be more or less adequately identified with 'concrete' and 'abstract' procedure. The opposition which exists between the two latter can be grasped immediately from the following record of a conversation with Mondrian made by Arp:

he opposed art to nature, saying that art is artificial and nature natural. I do not share his opinion. I think that nature is not in opposition to art.

This difference of opinion is not simply a matter of the status of the completed work of art. It can be traced, at a more basic level, to two differing conceptions of the artist's working procedure. Arp emphasizes, by choosing the title 'L'art est un fruit' for the source of the previous passage, that the work is engendered by an entirely 'natural' creative process. Mondrian, on the other hand, wrote in his essay on 'Natural and Abstract Reality': 'Only through man can nature become art. For that to happen, the human mind has only to transform, or to reform in plastic terms, all that nature causes our human natures to feel.' The following chapter will be devoted to a study of this process of 'transformation' through the human mind, whose goal is essentially an 'abstract beauty'.

If Mondrian is the artist whose work springs immediately to mind in this connexion, he is also an artist whose career has received extensive comment and criticism. The development of abstractive procedure in more recent painting is certainly a much more obscure question. For this reason, the first part of this chapter will be concerned with the contemporary painter whose work most vividly reflects the characteristic problems of abstraction.

VASARELY

The following quotation effectively establishes Vasarely's credentials for consideration as an abstract, rather than a constructive, or concrete, painter:

The work is not that which is confused with the surrounding milieu, but indeed that which is distinguished from it; art is artificial, the property

of creation is to become distinct from nature, and not to be confused with her.

As in the case of Mondrian, this principle of the absolute distinctness of the work of art raises an important question of artistic procedure. For Vasarely is no less determined than Mondrian that 'nature' must be taken into account at the initial stage of the artist's career. Between this original point at which he is simply confronted with the natural world, and the subsequent point at which his work is finally 'distinct', there must be a process of gradual divergence—away from nature and towards the 'abstract' solution.

Vasarely allows his views on this subject to emerge from a discussion of the career of Mondrian, who is understandably one of the two modern artists by whom he measures the stages of his own progress. According to Vasarely, Mondrian began to paint from a broad base of characteristic figurative material, and proceeded by a 'slow and patient abstraction of the world', in which 'elements of nature such as the earth, sea and sky are reduced to two constants: the horizontal and the vertical'.

Whether or not we accept as valid this description of Mondrian's procedure, which has been attacked by Hans Jaffé under the guise of 'camouflaged naturalism', we are bound to admit Vasarely's adherence to a similar pattern. Vasarely has composed diagrammatic drawings to illustrate the path of abstraction, in much the same way as Van Doesburg produced his famous series deriving from the drawing of a cow. But he has also followed the 'slow and patient' process, extending over several years, which is paralleled in Mondrian's work by the sequence of paintings dealing with the motif of the individual tree.

Although a number of Vasarely's so-called 'op' works date from before the Second World War, belonging to the period immediately after his training at the Hungarian Bauhaus (the Mühely), it was only in 1947, in the course of a visit to the appropriately named Belle-Isle, off the coast of Brittany, that the origins of his mature style became apparent. He has himself written of this visit: 'The sand, the shells on the beaches . . . the breaking of the surf, the mists over the sea, the sun, the sky . . . In the pebbles, in the pieces of glass from broken bottles, I am sure I recognize the inner geometry of nature.' (19)

This period at Belle-Isle is reflected in Vasarely's career by a sequence of works bearing the same name, and extending over the years 1947 to 1952. In one of the earliest of these, there is a direct comment on the personal reminiscence of the previous passage. Actual objects—pebbles and shells—are incorporated in the work. There has, however, been a radical process of selection, so that the progression of forms seems anything but random. A few years later, this process of selection has given way to actual abstraction. In the painting illustrated, the informal swirl of ellipsoid forms has been confined in a uniform order. But the connexion with the earlier stage is still quite apparent.

At this point a significant parallel with the work of Joost Baljeu may be introduced. Baljeu writes in his *Attempt at a theory*:

we pick up a pebble from the bottom of a river. Both ends of the stone are rounded off, it possesses an ellipsoid form as the result of the currents in the water and the grating over the sand, i.e. the counter-form.

Both artists are commenting upon the ellipsoid form of the pebble, and both artists use it to illustrate a general point about their creative procedures. But the uses which the pebble fulfils differ considerably. Baljeu could be said to *generalize* the relationship between form and counter-form, while Vasarely *particularizes* the form alone. Baljeu seeks for 'a dynamic equilibrium of tangible and environmental space under the influence of force and counter-force'. Vasarely, on the other hand, proceeds by a strictly *additive* method, whereby the various units of positive form and negative counter-form are simply juxtaposed—not in equilibrium but in disequilibrium. Where Baljeu has extracted two opposing principles of formation, Vasarely has retained the notion of nature's multiplicity and does not attempt to abstract or generalize beyond the sum of individual abstractions.

In describing Vasarely's principles in these terms, we are clearly going beyond the Belle-Isle period. We have moved from the last Belle-Isle paintings, in which the natural forms of the first group were still identifiable, to what Vasarely described in 1954 as the doctrine of 'pure composition':

PURE COMPOSITION is a plastic plane upon which rigorous abstract elements, few in number and expressed with few colours . . . possess over the entire surface the same overall plastic quality: POSITIVE–NEGATIVE. But by the effect of opposing movements, these elements give rise to and dissipate in turn a 'sense of space', and thus the illusion of movement and duration.

It is precisely from this point, when he had formulated his notion of 'Pure composition', that Vasarely began to insist on the autonomy of his art vis-à-vis the natural world. But this relationship of 'distinctness' did not signify that he had finally outgrown the necessity for reference to nature. A few years later, in 1960, he was able to define this relationship not so much as an escape from the old nature, but as an approach to a new nature which exists on a more fundamental level than landscape. This new nature could not be imitated. It could only be 'invented' in plastic terms.

Lingering traces of naturalism, under the form of *local colour, atmosphere, perspective, material* and *gesture*, pierce through the whole of pictorial abstraction, whether it be geometrical or lyrical. The milieu has left its mark upon us . . . I carry on the epic struggle against the old form which survives . . . I have managed to get away from this everyday landscape. The unapproachable: the stars, and the invisible: atoms, spring from my pictures after the event, that is to say after they are completed in plastic terms. It is no longer a question of inspiration from

present objects or beings, seen or remembered, but of the plastic invention of worlds which have up to now escaped the investigation of the senses. The world of chemistry, of bio-chemistry, waves, fields . . .

It is necessary to insist on the fact that Vasarely is not simply asserting the artist's right to use the microscopic and macroscopic worlds as his predecessor used the world of nature. In his view, 'to be inspired by a micro-photo or a fruit-dish are processes of the same order'. It is not the content of the work of art, but the new path upon which the artist is engaged, that leads to 'worlds which have up to now escaped the investigation of the senses'. The final implications of this view can only be drawn at the end of the chapter, but it is worth pointing out at this stage that the correspondence between the painter's experiment and the new scientific worlds is so far from intentional that the painter is actually 'troubled' by it:

I cannot keep myself from feeling a troubling analogy between my 'kinetic plastics' and the entirety of the micro- or macro-cosmos. Everything is there: Space, Duration, Corpuscles and Waves, Relations and Fields. My art is therefore once again transposing Nature, but this time that of pure physics, so as to make the world psychically comprehensible.

Vasarely therefore sets out to abstract from the forms of the natural world, but arrives eventually at a plastic formula which exhibits close parallels with the 'infinitely vaster nature' that is not immediately accessible to the human senses. This formula is the 'plastic unit', consisting of a geometrical shape inscribed within a square of contrasting colour. Although Vasarely has greatly modified the relationship of these units among themselves over the past fifteen years, he has retained to an extraordinary degree the essential features of his original principle. The remainder of this chapter will be concerned with the various forms which his 'plastic activity' has taken in the years between the discovery of 'pure composition' and the present day.

First of all, however, it is necessary to make a firmer comparison between his own aesthetic and that of the pioneers of the Modern Movement. Reference has already been made to the 'planism' of Mondrian, which Biederman represents as the crucial phase at which a choice had to be made between 'construction towards a new reality of nature' and 'destruction' of the old reality. For Vasarely, there is a comparable crisis at roughly the same time in the work of Malevich, whose 'black square on white' and 'white on white' represent for him the 'empty stage of the plastic drama'. But the respective solutions of Biederman and Vasarely are almost diametrically opposed. Biederman proceeds towards actual construction on the picture plane: Vasarely breaks down the 'metaphysical wall' of the surface by turning Malevich's square into an illusory third dimension. In short, Biederman vindicates the constructive principle by creating *actual relations of stability* on the plane surface. Vasarely accepts the necessary *instability*

which results from perspectival distortion of forms within an *illusory pictorial space*. Indeed he makes a positive virtue of this instability by calling it 'cinétisme'.

This relationship to Malevich helps to explain a curious tension in the work of Vasarely which is almost unique in the range of contemporary painting. While he is constantly dividing and distorting the illusory space of his works, he never loses sight of the fact that they must relate to a simple, three-dimensional projection. There must be 'a plane and more than a plane'. Surely the fact that the transfer of 'optical' designs similar to those of Vasarely into textiles was so uniformly disastrous springs in essence from this principle: that the complete rigidity and flatness of the plane must be sensed before the implied modifications of that plane can be sensed in their turn.

At this point there is a clear divergence from the work of a superficially kindred painter such as Bridget Riley. Miss Riley has accurately remarked: 'I think my conception of space is more American than English . . . I work in two dimensions, though the effect, say of a progression of circles through ovals may not give that impression.' In spite of the example given, the majority of Miss Riley's works are obviously two-dimensional in the sense that they induce the optical impression of a field which spreads towards and beyond the four boundaries of the canvas. With Vasarely, this 'spreading' effect can rarely be found: in fact the frequent division of his surfaces into formally distinct units is the direct antithesis of this procedure. The movement in Vasarely's works hovers backwards and forwards, into the third dimension and back to the picture plane, converging on central points or vortices of activity rather than extending to the four boundaries. Of course it also involves the spectator in reciprocal movements, so that the process of interaction is something like that described by Vasarely in 1956:

We are no longer on the surface, but in the object . . .
In approaching we draw further away . . .
In a corpuscle the sky opens infinite . . .
The components of the world have all kinds of aspects,
sometimes anarchic rumbling, sometimes structured ordering
according to the levels on which we place ourselves
the informal and the formal
proceed alternately up to the confines of
the inconceivable.

Vasarely's insistence on the plane surface as a medium for illusory movement has not prevented him from experimenting with various three-dimensional devices that might seem to belong more appropriately to the vocabulary of the constructive artist. But this apparent departure from his normal practice can easily be explained. His earliest important experiments in this direction were the 'œuvres profondes cinétiques' of 1953-4, which are the basis of a more recent series of multiples. These works consist usually of two squares of perspex, equal in area, which are placed directly

parallel to one another, at an interval of a few inches. As a result of this procedure, the picture surface is not so much broken as put into suspension. There is an overlap between the two formal schemes printed on the perspex, which lends an additional dimension of depth. But the spatial displacement between the planes themselves is not emphasized, as it might be in a conventional construction. On the contrary, the interest of the work still lies in the illusory presentation of a space which extends over and beyond the actual depth of the interval between the two planes.

In his series of metal reliefs, which were exhibited at the Pavillon de Marsan in 1963, and at the Kassel documenta in the following year, Vasarely departs from the plane surface in a much more decisive way. Cubic units are built up on the implied surface of the work, often in pyramidal structures which reach out towards the spectator. But, though these structures can be seen to be three-dimensional from the side, and have a much more obviously constructed character than the 'œuvres profondes', they are still ultimately concerned with the creation of illusory space. If the spectator stands directly in front of the work, the actual projection is almost impossible to detect. All that can be noted is a slight modification of the total field which is due to the incidence of light on the projecting surfaces.

Even the reliefs can therefore be shown to form a logical stage in the development of Vasarely's pictorial ideas. Indeed, when they are considered in the light of his most recent work, they seem to form a necessary prelude to his renewed investigation of the two-dimensional plane. Vasarely has always been anxious to demonstrate the dialectical principle in his work, and his recent sequences can be presented as the reconciliation, or synthesis, of two anterior stages. In the finest of his 'planetary folklore' series, which date from the early 1960s, the individual 'plastic units' often assert their separate nature, since they form a large enough section of the total field. (20, 27) These can be contrasted with the works of roughly the same date in which the units, though similar in structure, dissolve into the overall scheme: there is no obvious focus of attention, and the eye is led from point to point with no possibility of rest.

The pyramidal reliefs, which were exhibited in 1963, have little of this indeterminacy, since their structures are rigidly centralized. (21) The visual effect arises, as I have suggested, from the incidence of light along certain salient points of the pyramidal relief. In his recent series of *Permutations* (28), Vasarely has managed to recreate, and indeed intensify, this luminosity solely through an exact gradation of colour. Through such devices as silk-screen printing, which he employs with an exactitude that is surely unprecedented, he obtains an intense sensation of optical dazzle. But it is not the generalized optical dazzle produced by, say, the elaborate field structures of Morellet. It is a kind of dazzle which simulates the distribution of light on a metallic surface. In other words, Vasarely is using light to indicate structure and material, but both structure and material are illusory. And the intense illusion conveyed by

the central section of the work is not supported by the remoter areas, where the literal plane is allowed to form once more.

This recent series poses in the most direct form the problem of the spectator's relationship to the work. The gradation between intense illusion and the literal plane allows the spectator a chance to follow the structural logic of the composition. Although he can never entirely reconcile the actual with the illusory, he can test the possibilities of alternate involvement and detachment: he can explore a relationship which borders upon linguistic communication, in the sense the signs are both clearly stated and effectively subsumed in an overall system. Abraham Moles has written in relation to Vasarely:

the geometrical work offers the mind a point of rest, providing criteria for discrimination and judgement. The spectator thereby recovers his aptitude for disentangling values and enshrining them in clear thought.

What Moles refers to as the 'geometrical work' must not, of course, be taken to mean any geometrical work. In the 'synthesist' constructions of Baljeu, for example, the elements are rigorously geometrical. But the essence of the geometrical method lies in the artist's aim of 'synthesis'. Vasarely's aim is precisely to maintain a balance between overall scheme and distinct elements. By rejecting the notion of synthesis, and thus diverting the spectator's attention from the completed scheme to the path by which this scheme was set up, Vasarely provides a particular incentive to 'discrimination and judgement'.

Vasarely's place within this study of experimental painting is justified by his original concern with the two-dimensional plane, which has persisted up to the present time in spite of his considerable interest in other forms of expression. But it is important to remember that, like Baljeu, he sees the ultimate destiny of the plastic arts in architectural and environmental terms. He has sketched the various stages of development in a note dating from 1954, which is all the more relevant to this chapter in the sense that it justifies the consideration of abstraction as a dynamic procedure rather than an acquired method:

The famous passage from figurative to non-figurative is merely one of the stages in a profound transformation which is operating in the plastic arts. The word 'abstract' in painting does not in reality cover an acquired fact, but is an irresistible progress towards a plastic creation different from the one already known. I believe that we can no longer stand still after this 'passage' and that the abstract movement will inexorably cross the following stages: four of these can be distinguished (five, if you count the 'passage'). 1 The plastic element becomes unidentifiable. (Non-figuration) 2 The external vision is changed to internal vision. (First abstract stage) 3 Abandonment of all the habitual facture of painting, touch, *glacis*, materials, various other elements—(Pure colour, pure composition) 4 Abandonment of all the ancestral techniques —canvas, pigment, brushes—(Arrival of new materials) 5 Abandonment of the two-dimensional plane as a final goal and access to superior dimensions: space–movement–time (Urban and architectonic functions,

tele-cinematic projections, multiplication through the methods of the Imaginary Museum).

For Vasarely, the process of abstraction therefore transforms in turn the subject-matter, techniques, media and genres of plastic expression. But although the two-dimensional plane is finally abandoned, this does not mean that Vasarely has jettisoned the control of illusory space which is his main achievement on the traditional scale. The formula 'space–movement–time', which he uses for the final stage of the process of abstraction, is in fact the concise expression of the 'kinetic' ideal which he was propagating in 1955. And all Vasarely's architectural projects to date suggest that he is still concerned, even on the environmental scale, with the eternal ambivalence of the 'plane and something more than the plane'.

GROUPE DE RECHERCHE D'ART VISUEL: YVARAL

In the previous section, Vasarely has been treated from the point of view of the traditional painter. That is to say, it has been assumed that the relationship between this artist and his works can be equated to a great extent with traditional relationships of this kind. But any comprehensive study of Vasarely's thought would be bound to take into account certain principles which depart radically from the *status quo*. In 1960, Vasarely stated categorically that the 'solitary genius' was an anachronism: the future belonged to 'groups of researchers, collaborating with the aid of scientific and technical disciplines'.

The view of the artist as a 'researcher' is clearly relevant to the broader theme of this survey. And it is one which Vasarely himself has not merely commented upon. His own studio at Annet-sur-Marne requires technical aids of the greatest refinement, and employs several assistants who carry out the more laborious aspects of the preparation of works. Any organization of this type is bound to involve processes of research, if only in the sense that the marriage of human skill and mechanical technique is bound to result in unpredictable 'discoveries'. Yet Vasarely has stopped short at the vital dividing line between scientific and artistic collaboration. He himself remains uniquely responsible for the works which leave his studio, and he himself fulfils the functions of critic and creator. In 1965 he asserted that self-criticism could be 'creative', while the criticism of others was fated to be no more than 'instructive'.

By contrast, the Groupe de Recherche d'Art Visuel was founded expressly 'to combine the researches of individuals and small groups in order to make them more effective: to coordinate their activities in painting and sculpture, their efforts, capacities and personal discoveries in a programme of activity which aspires to be that of a team'. This 'Act of foundation', which the original members of the group published in 1960, also included the

prognosis that 'through a programme of research organized and sustained by their common examination of the work, ideas and "plastic activities" of each member', the group would build up 'a firm basis (both theoretical and practical) of communal experience'.

It will be obvious that the first requirement for a programme of this sort was a communal studio. This the group had already acquired by July 1960, at 9 Rue Beautreillis, Paris IV. A period of intense activity followed, as a result of which six members of the original team—Garcia Rossi, Garcia Miranda, Le Parc, Morellet, Sobrino, Stein and Yvaral—were able to exhibit in the 'Movement' exhibition at the Museum of Modern Art, Stockholm, in the early part of 1961. Later in the same year, all these artists, with the exception of Garcia Miranda, contributed to the first New Tendency exhibition in Zagreb.

Up to this point, the group remained close to the aims embodied in its chosen title. As was emphasized in a statement prepared for the Stockholm exhibition, the members preferred 'to consider the artistic phenomenon as an exclusively visual experience'. In March 1962, Yvaral composed a carefully considered statement in which much of the experience gained during these first months of visual research was clearly formulated:

The study of the visual phenomena produced by certain arrangements of surfaces or volumes, fixed or in motion, has been very rarely pursued in depth up to the present day. Our essential preoccupation is therefore to establish, before pretending to an acceptable creation, the codification of the signs, networks, structures and of certain physical or optical constants. It is for this reason that on numerous points our working method and our research technique come close to the method and technique of the man of science. In effect, like him, *we start from a datum which we exploit in an experimental manner forcing ourselves to control all its possibilities and outcomes* [my italics]. This research is related to the fruitful empirical method of the laboratory. In the process, the control of certain states, the hazards of discovery, make us see other horizons and progress even more rapidly towards our goal: the knowledge of the phenomenon of vision. But this comparison with the technique and the objectives of scholars leads us to a greater prudence in the choice of terminology. We cannot, in effect, pretend to know the precise accepted meaning of every scientific term: the language of mathematics and the vocabulary of technology are very unfamiliar to us. A close cooperation, contacts with the representatives of all branches of scientific research, are therefore necessary. So our ideas will become clearer, our goals will be attained in a more effective way. And it is not utopian to think that in the decades to come a vast synthesis will take place involving the confrontation of our ideas and discoveries and those of scholars.

This passage is of great interest, since it shows not only the extent to which the original experimental procedure of the group approached a scientific ideal, but also the extent to which it diverged. The activity of the group at this stage was not scientific, though cooperation with representatives of scientific research was en-

visaged. At the same time, it was achieving new knowledge of visual phenomena by the rigorous exploration of characteristic structures and networks. Comparison may thus be drawn on this level between the research of Morellet, a long-standing member of the group, and that of François Molnar, who left the group at an early stage to concentrate on the problems of experimental aesthetics. Although some of Molnar's early works belonged to the same context as that of his fellow members, his more recent work is primarily intended to demonstrate certain theoretical problems in the picture/eye relationship: for example, he demonstrates the variation in complexity in a basic scheme altered to a progressively larger extent. Morellet, on the other hand, is only concerned to show us the particular example in which his scheme attained an optimum balance between simplicity and complexity. One presumes that the communal criticism of the group was directed precisely towards this task of selecting the effective solution from a group of alternatives.

There is thus little difficulty in distinguishing the work of the group from that of the experimental aesthetician. This difference cannot be illustrated from a comparison of individual works, but resides in the contrasting approaches of the artist and the scientist. The latter aims to explain a phenomenon through a range of variables, the former to impress the spectator with a single optimal scheme. There is every reason to place the Groupe de Recherche d'Art Visuel within the artistic field, since they work through the traditional conventions of presentation, even if their aim is ultimately to subvert those conventions. But here it becomes necessary to reopen the question which I touched upon in the first chapter. Granted that the original programme and the initial exhibitions of the group satisfied this criterion of traditional presentation, there is considerable doubt whether they have remained within the field which they at first determined to explore. In answer to a questionnaire submitted by the author in 1965, Joel Stein maintained that the group was still fundamentally concerned with visual phenomena, even though 'situations involving other methods of conception, tactile works, darkened rooms, street demonstrations etc.' were envisaged as well. In following the course of the group's activity from 1965 onwards, we can reach some general conclusions about the possibility of conciliating visual with other sensory phenomena, traditional presentation with novel techniques of exhibition.

The main stages of the group's withdrawal from the commitment to 'exclusively visual experience' undertaken in 1961 can be traced in the following terms: from the 'exclusively visual experience' to the 'transformable work', which involves the spectator in 'real participation (manipulation of elements)': from the individual transformable work to the 'Labyrinth' or 'transposition on to an architectural scale' of the principle of spectator participation. The overall aesthetic change is from a doctrine which places extreme emphasis on retinal impressions, in the way that the

Impressionists and Seurat must have seemed to do in the context of their times, to the principle of participation on the level of the game. The Labyrinth which the group constructed for the 1965 Paris Biennale was in fact a series of 'salles de jeu', or games-rooms, which comprised such resolutely non-visual works as a spring-mounted seat that collapsed when the spectator sat upon it.

The 'game aesthetic' of the Groupe de Recherche d'Art Visuel is in one sense the final conclusion, and betrayal, of the path of abstraction. This is because the abstract elements which are still employed have completely ceased to operate on the representational level. The swinging sphere which is suspended from the ceiling is no longer an abstraction, but an object suitable for patting backwards and forwards. The polygonal wooden blocks on the floor beneath are simply the vehicle for a sensation of mild disequilibrium which the visitor experiences as he trespasses on to them. In other words, these elements have paradoxically returned from the abstract to the concrete. They simply exist as a coefficient for certain desired physiological reactions.

Yet the delicate balance between actual and illusory structures, which had originally been a feature of the work of the group in general, did not entirely disappear as a result of the adoption of the Labyrinth as a mode of exhibition. One member in particular determined at an early stage to maintain the original direction of his research, and to concentrate on exclusively visual problems. This member, Yvaral, who is in fact the son of Vasarely, deserves special attention for the additional contribution to experimental painting which he has made over the past five years.

It is perhaps necessary to establish from the first the point at which Yvaral began to express dissent from the common policy of the group. This purpose is served by quoting from the following text, written in April 1965, where Yvaral begins by underlining a common policy, but subsequently introduces important qualifications:

In brief, it is our aim to liberate 'the eye' from the mind by eliminating every extra-plastic criterion.

For some of us, the work constitutes the material of a game whose rules it carries in itself. The spectator is solicited to an active participation, whether he is to change his own position, or to manipulate the work . . .

For those who, like myself, are particularly interested in structural research, the project is not from the outset that of inviting the spectator to play. It is a matter of enriching the consciousness which the spectator may have of the specific nature of visual perception. In effect, what I personally would wish, is that, faced with a work whose meaning remains ambiguous, *the spectator may be able to operate an analysis of the relations of the real to the perceived* [my italics] in their diversity, and thus reach a more complete mastery of the mechanism of his own vision.

The similarity of this aim to that revealed in Moles' article on Vasarely is quite clear. Yvaral is also anxious for the spectator to

have the 'point of rest' that physical participation is likely to upset. Just as Moles entitled his article 'Vasarely and the triumph of Structuralism', so Yvaral's remarks bear a direct analogy to Roland Barthes' view of the structuralist attitude to reality. Barthes has written of structuralist man as 'the fabricator of meaning' rather than 'the possessor of particular meanings'. He claims that 'the thing that is new is the form of thought (or 'poetic') which is concerned less with assigning full meanings to the objects which it comes upon, than with knowing how meaning is possible, at what price and through what channels'. Yvaral's aim of communicating 'a more complete mastery of the mechanism of one's own vision' is in fact a plastic parallel to this poetic. The shapes and figures of his works cannot be equated, as Moles equates those of Vasarely, with 'the universals of our technological age'. On the contrary, they are no less negligible in formal terms than the balls and boxes of the other members of the group. Yet they are not being used to stimulate involvement on the level of the game. They are devised and ordered so as to enable the spectator to gauge the 'possibility' of visual 'meaning'—'at what price' it is possible, and 'through what channels'.

Yvaral has remained consistent with the views which he expressed in 1965. While the other members of the group have tended to follow the logic of participation, his work has taken an almost opposite direction. Some of the objects which he contributed to the 1965 Biennale did invite a measure of active participation from the spectator—in the spinning of a work upon its axis, for example. Yet even here his contribution was both in physical and doctrinal terms an adjunct to the main exhibit. Since that date, he has concentrated chiefly on two lines of research which involve a balance between 'the real' and 'the perceived', but are not dependent upon manipulation. These two branches can be identified in one case by the use of the moiré effect, and in the other by the use of statistical distribution of pictorial elements.

The studies which employ the moiré effect hardly fall within the sphere of our concern, though many involve the exact duplication of transparent surfaces which has already been mentioned in the case of Vasarely. Suffice it to say that this is a clear case for the analysis of the relationship between the real and the perceived. Moiré effects involve a highly perceptible distortion of linear patterns which remain at the same time perfectly regular if they are examined more minutely. Yvaral chose for a number of his works in this field, which date from as early as 1962, the title of 'Accélération optique'. (25) This is an accurate term, since the sensation felt before the work is in fact one of heightened and accelerated optical reaction: the work's fascination lies in its perpetual capacity to elude us.

Yvaral's numerous studies of the plane surface, which extend over an even greater period of time, usually depend upon the systematic development of a particular motif. For example, what

appears merely as a white oblique line at the outside edges of a rectangular area may increase in size, as if it were an averted plane turning towards the spectator, in proportion to its closeness to the centre: eventually, at the central point, it becomes a full square. Alternatively, a series of vertical black lines may be modified by an increasing number of twists according to their nearness to a central line, which is itself therefore twisted throughout its length. (24, 29)

The interest in centrality as the dominant organizing factor in the pictorial scheme, which is apparent in both these descriptions, sets Yvaral apart from his colleagues in the group who have attempted similar exercises. Both Morellet and Stein, for example, produce entirely homogeneous patterns of repeated elements, in which there is no alteration in density between the centre and the edges of the rectangular area. (23) The dividend of Yvaral's approach is that the centralized work genuinely functions on a pictorial level, whereas the entirely homogeneous field belongs to its rectangular format merely for convenience of presentation. Morellet and Stein obtain an overall vibrancy in their surfaces and provoke strong reactions on the physiological plane. Yvaral, however, is able to achieve a much more refined quality of space irradiated by light. In his black and white works, the receding central space is at the same time the source of an outgoing radiance. In his coloured works, the effect is more subtle. A recent series of studies in gouache, destined to be published as a series of prints, employs the contrast of blue and vermilion to provoke a particularly intense spatial paradox. The colour lies richly on the surface, yet releases us into a vibrant area beyond the picture plane.

By comparison with his colleagues in the Groupe de Recherche d'Art Visuel, Yvaral has chosen to concentrate upon the visual problems more directly analogous to the traditional concerns of painting. His studies of superimposition and transparency, for example, recall some of the experiments of Moholy-Nagy. His manipulation of the plane surface clearly takes as its point of departure the work of Vasarely. Yet it would be entirely wrong to conclude that he is simply running through a repertoire that has already been established. The cardinal point at which he differs from Vasarely, and from the artists of the previous generation, is in his unqualified acceptance of programmed sequences to determine the structure of the work. This is a point which he holds in common with his colleagues in the group, and indeed with many young European artists. Yet his adherence to the centralized composition, and his acute sense of light and space, give his programmed works a highly personal flavour. He brings us squarely face to face with a process which no other artist of his generation illustrates so vividly and so concisely—that of the overall form not predetermined by the artist, but arising, so it seems, before our very eyes.

BERNARD LASSUS

It is evident that in many respects the artists whose work is described in this section hold views exactly contrary to those following the constructive trend. A difference of particular significance is the fact that the constructive artist values the aesthetic factor of equilibrium or stability. Vasarely, on the other hand, proclaims his commitment to instability. His original cultivation of 'the effect of opposing movements' was reflected in the programme of the Groupe de Recherche d'Art Visuel, who actually called their exhibition at the Maison des Beaux-Arts, Paris, in 1962, 'L'Instabilité'.

It would be natural to conclude that, because of this basic disagreement, the constructive artist tends towards architectural forms while the 'abstractive' artist prefers the illusionistic and kinetic possibilities of the picture plane. Yet, as we have already noticed, Vasarely is in fact deeply committed to the ideal of working on a wider scale. The real distinction, one might say, is not between an architectural and a pictorial sensibility, but between one approach to architecture and another which is diametrically opposed to it. As I suggested previously, Vasarely is still effectively concerned with the problem of 'dissolving' the plane surface in optical terms, even when that surface exists on an architectural scale.

However, neither Vasarely nor the members of the Groupe de Recherche d'Art Visuel have penetrated sufficiently into the architectural milieu to attempt the formulation of an architecture which is 'anti-constructive'. This has been the achievement of Bernard Lassus, who has undertaken an exhaustive analysis of illusion and the pictorial surface over the past fifteen years, but always directed his research towards the ultimate purpose of revitalizing architectural forms. In contrast to Baljeu—the artist proceeding logically in the direction of constructive architecture— we have an architect proceeding towards the solution of architectural problems through a course of controlled experiments on a pictorial and sculptural scale.

The antithesis between Lassus' method and the constructive approach is excellently conveyed by a juxtaposition of his own opinions with those of Van Doesburg. For the texts which follow, I am indebted to the publication of a group of architectural students, which was produced on the occasion of two lectures by Lassus in November 1964.

Van Doesburg wrote of his decorative scheme for L'Aubette, Strasbourg, that he had intended 'to employ durable materials only'. But because of the problem of cost he was forced to abandon this principle. 'I see myself obliged to impose restrictions upon myself in this matter,' he wrote, 'and employ rather 'illusionistic materials' like colour, as a means of expression . . . the paintwork of the ceiling and the walls is executed in 'relief' and this is for two reasons; in the first place because I was thus able to achieve

a better defined surface, and the super-radiation of the colours was avoided, in the second place because the fusion of two colours was thus absolutely impossible.'

Lassus sees the task of the architect not as one of reducing the illusionistic features of colour, but of emphasizing and utilizing them.

The form of colouring which consists in confirming or affirming the structure of a building seems to me at the present moment the one most utilised, but this use of colour, which one can qualify as descriptive, does not seem to me to cover the diverse possibilities of colour.

I would like it to be considered equally as a form of transition, as a communication, for it is also a unifying property.

As its nature consists in being subject to change, it corresponds to the expression of mobility, it tends towards the fluidity of form which is not only a function of light, whether artificial or not, but also of the different angles of view according to which the forms are seen—from a car, or on foot. Man no longer constructs solely rocks and trees, but also clouds and fluids.

This passage can be interpreted as an attempt to transfer to the architectural scale the aesthetic developed in connexion with kinetic art. Lassus is ready to envisage the building or group of buildings not as a series of isolated constructed forms, but as a series of masses which are liable to constant transformation by light and other natural forces. In his view, the architectural form should be planned to comply with this inevitable destiny. It should not be conceived in antiseptic geometrical purity, as if the rhythms of the natural world did not exist. Of course, this approach creates considerable problems for the architect. He must clearly avoid modifying the constructed form to such an extent that the users of a building are hampered in their everyday functions. Lassus anticipates this objection by making special provision for it in his theoretical scheme. He makes a broad distinction between the 'tactile' scale and the 'visual' scale. The former is 'the one in which we move, in which it is often necessary for us to take cognisance of ourselves with precision. One must be able to park one's car and situate the steps of the staircase'.

Of the visual scale, Lassus writes as follows:

Beyond this tactile scale, or side by side with it, there is situated a visual scale, that is to say a zone where phenomena, even if they provide us with different types of sensation, are solely visual; on this level we have no reason in principle, other than aesthetic or in some cases psychological reasons, for embarrassing ourselves with considerations of respect for existing volumes. Here we are more free.

Why should we make the inhabitant or visitor submit to a visual description of the principle of construction, which may interest the technician, but is perhaps not the ideal visual urban climate to be desired in all cases ?

This method of approach, which is more sensory, more visual, impels me to reverse the form-colour relationship to colour-form, since it is colour by which we take stock, in visual terms, of our surroundings.

Colour as the appearance of volume at the same time provides a form

for this appearance, a form which is necessarily fluid, since colour is narrowly bound up with light and both are changeable.

Seen from this point of view, architecture is a composite of sensations whose variations are foreseen.'

Naturally these variations can only be foreseen if the architect has a great preliminary knowledge about the operation of light on various surfaces, and so on. It was to obtain this information that Lassus founded the Centre de Recherche d'Ambiance, which has undertaken a long series of experiments in order to discover certain general principles which were by no means evident from the start. The following list of objectives shows how closely Lassus touched upon the problems of the painting and the pictorial surface.

To acquire a better knowledge of the divergences between observed form and constructed form, we propose to study optical and tactile illusions which create a suggestion of space.

—On the one hand we shall seek to clarify the notion of visual depth by studying direct and diffused reflections, in particular the grouping of elements that reflect each other mutually.

—On the other hand we shall seek to clarify the notion of material depth.

—Ultimately we shall seek to study the largest and the smallest area of extent which the same surface is capable of offering.

For example: starting with a surface of 1m. × 1m. we shall study how this surface appears larger or smaller in relation to:

 —its characteristics (colours, surface states, degree of brokenness)

 —the context in which it appears (on another surface or isolated in space)

 —conditions of observation: variations in the vertical or horizontal distance in relation to the spectator, and variations of lighting.'

Despite the fact that these experiments were clearly intended to serve as models for architectural schemes, Lassus has exhibited them in public on several occasions. He took part in group shows at the aptly named Galerie d'Art Socio-expérimental, Rue de Bellechasse, in 1963 and 1964, and has exhibited twice at the Maison des Beaux-Arts. In addition, he has been accepted as a kinetic artist on the same terms as more traditional painters and sculptors, and has taken part in such exhibitions as 'Lumière et Mouvement', which was held at the Musée d'Art Moderne de la Ville de Paris in 1967. His recent contributions have tended to be entire 'ambiances', rather than single objects.

The ultimate judgement on Lassus' work must however be reserved for his architectural projects. Some of these are already complete, such as his decorative scheme for the Houillères du Bassin de Lorraine and his fine mosaic for the Groupe Scolaire Jacques Sturm at Strasbourg. But none has yet achieved the grandiose proportions of the prospective 'Etude d'ambiance' made in 1968 for a large site, called La Coudoulière, on the Mediterranean coast. Here it is not the individual building that is being adapted, but the entire landscape, which must accommodate a substantial

D

holiday village. The scheme provides excellent material for tracing the full implications of Lassus' attitude to nature, and his place in the path of abstraction which is the subject of this chapter.

First of all, it should be explained that the experimental process which has been described does not take place exclusively within the laboratory. Besides his exhaustive studies of light and surface, Lassus has set himself the wider task of 'analysing the evolution of the design and the colours of the motifs in folklore costumes of typical villages . . . analysing the traces and additions left by the inhabitants themselves on façades, balconies, courts. . . .' At the beginning of his 'Etude d'ambiance' for La Coudoulière, he indicates that he has brought into play his knowledge of the architecture of Georgia, 'for the way in which it utilizes vegetation to manage transitions between interior and exterior spaces with the help of multiple terraces and deep balconies'.

There is a parallel to be drawn between this inductive procedure, whereby Lassus selects certain motifs and certain usages from the architecture of a foreign culture, and the 'process of abstraction' which Vasarely has described as the initial step in the formation of an abstract style. It is not adequate to maintain that Lassus is simply transferring architectural motifs from one culture to another. For he is in effect drawing on the fields of both nature and culture, refining the material which he collects with reference to his exhaustive programme of research, and finally assembling his new 'ambiance'.

This point becomes more significant if we refer once more to the structuralist positions which have already been invoked in the discussion of Vasarely and Yvaral. Reference has been made to the way in which Vasarely takes conventional nature as his starting point and works towards the discovery of 'an infinitely vaster nature'. In order to identify a comparable process in the work of Lassus, it is necessary to extend the quotation from Roland Barthes' essay on 'Structuralist activity' which has already been quoted:

According to Hegel, the ancient Greek was amazed by the *natural* in nature; he listened to it continually, and demanded the meaning of springs, mountains, forests, storms; without knowing what all these objects said to him one by one, he perceived in the order of the vegetable world and of the cosmos an immense *frisson* of meaning, to which he gave the name of a god, Pan. Since that time, nature has changed, and become social: all that man encounters is *already* human, including the forests and rivers that we cross on our journeys. But before this nature become social, which is quite simply culture, the structuralist does not differ from the ancient Greek: he also lends an ear to the natural element in culture, and perceives there all the time, not so much stable, definitive, 'true' meanings, as the *frisson* of an immense machine which is humanity in the process of moving tirelessly towards the creation of meaning, without which it would cease to be human.

Is this conflation of nature and culture the 'infinitely vaster nature' of Vasarely? Is the link which he discerns between his own plastic

experiments and the scientific notions of waves and fields simply due to the fact that both are the product of man's urge to create meaning, through systems of signs, where no definitive meaning is possible? In all events, Barthes' principle has an immediate and direct relevance to the work of Lassus, which implicitly assumes the unity of nature and culture, and springs from the urge to accommodate both within a unitary system of signs.

Clear evidence of this fact can be found in his *Ambiance 14*, which is in effect a dining room for the President of the Renault works at Billancourt. (30) This project is roughly based on the form of a figure of eight, with one circle filled by the dining table and chairs and the other empty except for a ring of easy chairs. The opposition, in Lassus' terms, is simply that of the 'creux' and the 'plein'—the hollow and the full. But the whole of the area is lit by the diffused glow from the surrounding plastic wall panels. Hence a principle of variation is needed to set off the particular quality of this artificial light, and to underline the contrast between the character of the two internal areas. Lassus fulfils this requirement by having a gap of one panel in the wall, through which a dark green tropical garden can be seen against the daylight. 'Nature' is therefore introduced as part of a system of oppositions which mutually reinforce one another. It is interesting to note in parenthesis that Lassus manages the transition from internal to external areas through a progressive 'shifting' of signs. He takes as a firm principle that there should be no juxtaposition of unlike colours and materials at the same time. If a transition is made from carpet to paintwork, then the same colour must be retained. If the transition is from one colour to another, the material must remain the same. In this way, the passage from one area to the other is expressed in terms of successive relationships of affinity and dissimilarity.

With this work in mind, the plan for La Coudoulière acquires new significance. Lassus writes: 'A house placed on the fringes of the pinewood would be very broken up and would not present vast uniform surfaces, the claddings of the houses beside the beach would relate to the beach by their surface states and by their colours.' Lassus' aim seems to be that of obtaining a continuum, in which nature exists not merely as one side to an equation, but as part of a system where all natural and constructed forms are given 'meaning' by the consistent application of a series of binary oppositions. This is an enormous task, as Lassus recognizes in his 'problematic' for La Coudoulière. But it is perhaps the logical conclusion to a view such as that of Barthes, which posits first and foremost man as a 'fabricator' of meanings, and tends to annihilate the barriers between fabrication on the scale of the traditional art-work, and fabrication of an entire environment.

It was a commonplace of the later eighteenth century that the treatment of landscape in pictorial terms was copied by the landscape gardener, who in this way created a 'picturesque' form of nature. There is a close parallel in the procedure of Bernard

Lassus, who accustoms us on the scale of the exhibition to pheno-
mena of space, light and colour which he then recreates on the
scale of architecture and planning. But Lassus' method is not to
transform natural surroundings by interpolating types of arrange-
ment that were originally developed in a plastic medium. On both
levels he is experimenting with the same constant features of the
physical world, and the laboratory work simply enables him to
exert a measure of control over what had previously been thought
uncontrollable. Ultimately this degree of control which he is
acquiring is not to be thought of in exclusively physical terms.
The point is that the environment should reflect, to one who is
conversant with the architect's programme, a methodical system
of related and distinguished signs. Vasarely's point about the
'distinctness' of art and the 'surrounding milieu' is therefore
radically reformed. They are indeed distinct, but their distinctness
is itself a feature of an overall system. The artefact is artificial,
but so is the milieu, in so far as it has been endowed with meaning
by the architect.

This structuralist vision of the world is arguably the ultimate
stage in the path of abstraction. Yet in a sense it is already implicit
in the words of Mondrian:

Man, by growing, transcends and goes beyond nature; thus the expres-
sion of his vital force changes. He followed nature as long as the natural
was dominant in the spirit of the age; but with the maturation of the
natural in him, the naturalistic representation of vital energy could no
longer satisfy him. At that moment his human consciousness, more
complete, already contained a new interpretation.

4 Paths of experiment: destruction

The 'constructive' approach of Charles Biederman is founded on the belief that there has been a prolonged 'crisis' in the relationship of art to nature. Biederman views Courbet as the last master of the 'old realism', and posits a subsequent divergence between the art of photography, which 'was devised in order to continue the art of the old reality,' and Cubism 'as a construction towards a new reality of nature'. He condemns any attempt to close this gap as 'destructive', a stigma which he attaches to the attitudes to nature adopted by Juan Gris, Mondrian, the Surrealists and the Tachistes. His conclusion is a decisive one: 'Today painting is in a death struggle with nature'.

It is possible to accept this analysis by Biederman without in any way subscribing to the conclusions which he would wish to be drawn. The notion that destruction is the other side of the coin of creation is one that many painters would readily concede. Picasso has remarked epigrammatically that the painting is the sum of destructions. Mondrian has claimed that each stage in the evolution of art results 'solely from the destruction of prior creations'. A painter like Francis Bacon is ready to admit that the invention of photography accelerated the destructive process, but he remains none the less committed to that process, as the following passage makes clear: 'Photography has covered so much: in a painting that's even worth looking at the image must be twisted . . . if it is to make a renewed assault upon the nervous system . . . and that is the peculiar difficulty of figurative painting today.'

The attempt to describe destruction as a path of experiment, in the same way as construction and abstraction, does however encounter an initial difficulty. Both the previous directions derived, in essence, from the particular strand of the Modern Movement represented by Constructivism, De Stijl and the Bauhaus. Destruction can certainly be associated with the contrasting aesthetic of the Dada movement, and with the Surrealist tradition. But it appears to have its origin as an aesthetic principle in the wholesale inversion of artistic values which was a feature of the Romantic movement. The following passage, in which Huysmans characterizes the genius of Delacroix, supplies many of the concepts which are relevant to this new psychology of creation:

Unequal and abrupt artist, a Rubens deplenished and refined by neuroses . . . Delacroix has the grace of maladies that are ending and health that is returning. Nothing in him of the usual routine, of settled life, of the retired businessman of sagacious art, but starts, exultations and ill-checked rearing of the nerves, which transcend the decline all the same and keep it within bounds; on the other hand, it is a breakneck pace all the time . . . and if the ill-chance of a temporary lack of visual energy is brought into account, all is spoilt and he becomes singularly inferior; his passion which he struggles to whip up starts to bridle and then tones become thicker, the incomplete draughtsmanship errs

and falters . . . All in all, he has infused into the painting of his times, in place of health, a last-ditch bravura, a nervous fluid, an intermittent force of anger, a pulse of love.

Huysmans' main achievement in this passage is to obliterate the notion of technique as a set of fixed modalities for making plastic form of the forms of the external world. Indeed any idea of reference to the external world can only be of secondary importance. The artist's procedure consists essentially in a hazardous operation upon his own personality, which can easily degenerate into a futile attempt to 'whip up' reserves of feeling. At its best, it is an extreme venture, poised upon the boundary between sickness and health.

I would suggest that there is an intimate link between this view of the artist as a psychological adventurer, and the theme of destruction as a counterpart to creation. One very obvious explanation is the fact that, while the construction or constructive intent of a work will be apparent both on the metaphorical and the material level, the destructive intent of a work cannot, except in very recent cases, extend to the actual material and composition. Violence can be represented only through stabbing brushstrokes, for example, or strongly accented angular planes. Order and stability can be powerfully underlined, as in the case of Biederman, by the actual physical construction of the work.

The destructive procedure is therefore closely allied to a kind of psychological experimentalism, which is itself a response to the artist's total dissatisfaction with conventional modes of representation. Gabrielle Buffet-Picabia provides a satisfactory model of the situation when she writes that Picabia 'exceeded the limits of his creative field by an exasperation of his lyric vein, always under pressure; he abandoned himself to chance and to his exceptional imaginative faculties . . . pursued the disintegration of the concept of art, substituting a personal dynamism . . . for the codified values of formal beauty.' Francis Bacon reiterates in a more concise form the logic of the self-inflicted experiment: 'I have deliberately tried to twist myself . . . My paintings are, if you like, a record of this distortion.' He is also deeply aware, like Picabia and indeed like Delacroix, of the external world as a place of contingency, and not as a repository of structural order. In 1850 Delacroix wrote in his Journal: 'Say what you will, humanity is at the mercy of chance.' More than a century later, Bacon echoes him:

Man can now only attempt to beguile himself, for a time, by prolonging his life—by buying a kind of immortality through the doctors. You see, painting has become, all art has become, a game by which man distracts himself . . . You know in my case all painting—and the older I get, the more it becomes so—is an accident.

GIACOMETTI

The previous quotations have shown a significant connexion, in the case of three very different artists, between views of the artist's psychological state, his creative (or destructive) procedure and his concept of the external world. All of these elements are linked once again in the works and writings of the painter and sculptor Alberto Giacometti, who belonged loosely, like Picabia, to the Surrealist movement, but went far beyond this initial point of departure. In Giacometti's commentary on Derain, which was written in 1957, we have a remarkable statement of the dilemma of the contemporary painter which reflects Bacon's remarks, but includes some vital points of difference:

Derain's qualities are such that they survive failure, frustration or possible catastrophe, and these are the only qualities I believe in, at least in modern art . . . Derain was continually being overtaken by his surroundings; impossibility terrified him, and every work spelled failure for him before it was begun. None of the assumptions, none of the certainties upon which most, if not all, contemporary painting is based, even abstract painting, even tachism, had any meaning for him; how then did he find means to express himself? Red is not red, a line is not a line, volume is not volume, and everything is contradictory, a bottomless pit in which to founder. Yet perhaps he only wanted to capture a little of the appearances of things, the marvellous, fascinating, inscrutable appearances surrounding him.

The main point at issue here is that whereas Bacon emphasizes the need to 'twist' the self and sees art as a 'game', Derain is portrayed as a painter intensely preoccupied with the external world, who is none the less 'continually overtaken by his surroundings'. In other words, the procedure which, in Bacon's terms, reflects a primarily psychological compulsion, depends in the case of Derain on a repeated attempt to come to terms with the 'inscrutable' world of appearances. It is this attempt, undertaken with the clearest prospect of failure, that provides the main interest of his work. And to Giacometti the total failures of his career must be seen in company with the relative successes in order that this interest may be borne out. 'I cannot admire a painter's work,' writes Giacometti, 'without admiring the bad, the worst of his paintings.'

Here is a view of the artist's role which may or may not be adequate in discussing the career of Derain, but is certainly of prime importance in assessing Giacometti's own work. For Giacometti, the artist is engaged in a perpetual quest for which no definitive answer can be imagined. Indeed, even if such an answer were conceivable, it would not, in Giacometti's terms, be desirable. 'Art and science is trying to understand,' he writes. 'Success and failure are entirely secondary.'

The reference to scientific procedure leads to an interesting parallel with the 'research' of the Groupe de Recherche d'Art Visuel. In their case, the goal of research is clear enough. In

Yvaral's words, it is 'knowledge of the phenomenon of vision'. Yet this distinction between the quest which has a specific goal and the one which has not is hardly the only point of difference. A logical consequence of the two approaches is that the group should see their works in series, as progressive steps towards the know-ledge of vision, while Giacometti must view each work as an end in itself—despite his insistence on the continuous process of 'trying to understand'. Jean Genet has expressed with memorable intensity this self-sufficiency or 'solitude' of the individual work that he finds in the paintings of Giacometti:

If I observe the picture . . . it manifests itself to me in its absolute solitude of object as picture. But that is not what I was concerned with, I was concerned with what might be represented in the canvas. So it is at the same time this image which is on the canvas—and the real object which it represents that I wish to seize in their solitude. I must therefore try to isolate as far as its own significance goes the picture as object (canvas, frame, etc.) so that it ceases to belong to the immense family of painting . . . so that the image on the canvas relates to my own ex-perience of space, to my knowledge of the solitude of objects, beings and events . . . One who has never been amazed by this solitude will not come to know the beauty of painting.

Though Giacometti's procedure is experimental in the sense that it involves repeated attempts at insoluble problems, it cannot be identified with a particular objective or programme: this is, after all, the 'certainty' which he spurns. For this reason, the only satisfactory index of this procedure is the attempt to come to terms with the individual painting, or rather the individual model. Sometimes this confrontation does indeed become a protracted struggle between the painter and the world of uncertain structures and fleeting appearances. Genet has described in these terms Giacometti's attempt to paint the portrait of Isaku Yanaihara, whose oriental features presented an almost insoluble problem to the artist's essentially linear schemata.

What then is the final aim of Giacometti's paintings, and par-ticularly of the portraits which formed by far the largest section of them? Since he is wary of the conventional illusionistic styles, he tends to concentrate on methods which are more properly those of the draughtsman than the painter. This is not because he has abandoned the simple aim of communicating his vision of the external world. Quite the contrary, his determination to avoid all ready-made solutions is an index of his desire to 'capture a little of the appearances of things'. He aims for an image at once absent and present, schematic and yet, as Genet puts it, 'of an unbreak-able hardness'. The best of his portraits seem to hover between life and death, just as Delacroix' works were said to hover between sickness and health: 'the faces painted by Giacometti seem to have accumulated every ounce of life, to the point where they no longer have a second to live, not a gesture to make and . . . where they at last know death, for too much life has been accumulated in them.' (33–35)

This final ambiguity of the pictorial image is the proper result of a procedure which is at once destructive and creative. Giacometti's method of creating a vivid image is not through blending tones and imperceptible outlines, but the repeated stabbing and scribbling of the instrument which he holds in his hand. He himself has left a memorably concise description of the urge to probe beyond the pictorial surface which is at the same time an impassable barrier: 'It is as if reality were continually behind curtains which one is tearing away.'

FRANK AUERBACH—MICHAEL ANDREWS

Giacometti cannot be called the head of any group or school. But the view of the painter's role which his works exemplify is not so much an accepted dogma as a possible conclusion from widely shared opinions of the painter's predicament in the contemporary world. Consequently it is not surprising to find similar approaches to figurative painting in the work of two younger British artists, Frank Auerbach and Michael Andrews.

The initial features of Auerbach's procedure are apparent from the two *Studies for the Sitting Room* which are illustrated here. (36) The first is a conventional drawing, which recalls in style the artists of the Camden Town Group. The second is a reinterpretation of the same scene which is closer to Giacometti. Instead of the bland perspectival recession of the first example, there is a much less assured sense of space: the pencil strokes seem to rove across the surface, picking up vague outlines in the area which is denied to them by the barrier of illusion.

Despite this example of a domestic interior, and a large number of works which deal with London landscapes such as Primrose Hill, (38) Auerbach resembles Giacometti in concentrating much of his attention on portraits, often of close friends. He sees this habit as potentially risky: 'with someone one knows one's got to destroy the momentary things. At the end comes a certain improvisation.' In all his work, however, there seems to be a similar compulsion to destroy the inessential, even up to the final stage of all. 'I always finish pictures in anger,' he affirms. Again he admits that the feature which 'thrills' him about the work of other painters is 'a vision pushed to its extreme'.

It is relevant to introduce at this point Huysmans' judgement on Delacroix: 'his passion which he struggles to whip up starts to bridle and then tones become thicker'. The danger in Auerbach's extreme vision is that the bravura will cease to buoy up the highly worked pigment and the surface become inert rather than alive. Perhaps it is because of this danger of the broadening and coarsening of tones that *Figure on a Bed* (1966) sets the reclining figure off against a neutral background of varying surfaces. The architecture of the whole picture does not therefore depend on the architecture of the human figure as it emerges from the riot of pigment. (39)

Auerbach has himself drawn a distinction between the dogged-
ness of Rembrandt and the gaiety of Tintoretto, two qualities
which he sees as the 'polarity of what could be called good paint-
ing'. Viewed as a whole, his career might seem to indicate a shift
from the former to the latter, in the sense that his structures have
become more fluid and his colour range much more extensive.
But 'doggedness' still remains an accurate description of his
approach, determined as it is by his distinctive sense of material.
This is emphasized by a passage in which he defines his procedure
as a painter in a way which exactly fits the theme of this study:

The consciousness—the strictness and then the image. The image, the
good painting, is the result of conscientious experimentation—conscien-
tious roots—one has to be true to that, I mean the object, then one's
more likely to get a unique result.

This repeated reference to the need for 'conscientious' experiment
posits a scale of values which can perhaps best be explained with
reference to the Romantic movement. For Auerbach's commit-
ment is not to a traditional set of moral values, but to the im-
possibility of maintaining any such values. 'One gets suspicious of
love, of religion, of everything', he writes. 'In the end, it's im-
possible. In painting one can destroy it.' The view recalls Morse
Peckham's judgement in the essay, 'Towards a theory of Romanti-
cism': 'Only with the breakthrough into modern art did the
romantic artist and thinker learn how to break down an orienta-
tion without partially disintegrating his personality.' Auerbach,
like Giacometti, is engaged upon a path which involves the destruc-
tion of prior 'orientations'. His commitment to the act of painting
depends radically on this fact.

Michael Andrews, whose earlier exhibitions took place, like
those of Auerbach, at the Beaux-Arts Gallery, provides a close
parallel to this form of commitment. If his paintings do not
provide the immediate evidence of 'dogged' application, his
description of the artist's procedure lays strong emphasis on the
need for sheer continuity of effort:

The painting episode is a real situation imagined. Re-enacted and
rehearsed until its performance is the best possible. There is nothing
like it in public life except for coincidence or a game that's both wilful
and conscious . . . Everything is provisional, changing, reverting, need-
ing to be done over and over again, revised, altered, reset . . . The image
only reveals itself after continuous painting for long periods—actual
physical continuity, not the thing simply borne in mind and returned to
—though that *can* work.

Andrews has also written: 'Do it as painting (form) not as if
constructing a thing.' The distinction is interesting because it
brings back into focus the divergence between the modern figura-
tive painter and the constructive artist which Biederman insists
upon. All the painters who have been mentioned in the course of
this chapter would corroborate Andrews' view that the metaphor
of construction, however relevant it may have been at certain

periods in the past, is totally inapplicable to modern figurative painting. Does this mean that we should therefore accept Biederman's premise that their art is 'an "attack" upon nature, in the effort to secure the survival of painting'?

The issue is a complicated one, and it is by no means solved by Bacon's habit of presenting the act of painting as a mere distraction. Part of the answer lies in the fact that the element of 'destruction' arises in the artist's desire to break down his 'orientations'. In Andrews' case, this takes the form of a strong desire for spontaneity, a refusal to accept the formalization of experience. 'It's no good mentally reconstructing impressions,' he writes, 'one must wait for them to actually recur.' But even if one admits that the destructive traits of the painter's style are in large measure a corollary to his psychological processes, there is still justification for using Biederman's concept of an 'attack' on nature. The essential point is to see this in the context of the modern figurative painter's distinctive relationship to nature. (40)

Take first of all the model for the constructive artist's relationship to nature which applies to the work of Biederman and Baljeu. The constructive artist is 'parallel' to nature: there is a direct analogy between the forms of his reliefs and what Biederman calls the 'structural process level' of the natural world. With the painters who have been under discussion, the relationship is not one of equilibrium: it is intensely problematic. And this is because a painter like Giacometti does not look for analogy between structures. He looks for life itself, which is why Genet's remark about the accumulation of life and the knowledge of death in his portraits penetrates so deeply their ambivalent status. Such a painter must be conscious all the time of the impossibility of his aim, and resort, as Michael Andrews does, to the desire for an almost magical conjunction of the real and the represented world—'to feel as if I am placing the brush on the place on the real thing'. But the primary requisite, without which such a ritual has no meaning, is for a projection of feeling towards the world that is necessarily so intense that it merits the name of 'attack'. As Michael Andrews urges: 'One must believe, desire, *love* . . . the atmosphere one creates.' In terms of Huysmans' analysis, the 'intermittent force of anger' is hardly to be distinguished from the 'pulse of love'.

GUSTAV METZGER: AUTO-DESTRUCTIVE ART

It should be emphasized once again that this chapter is not concerned, as the previous ones have been, with tracing a more or less coherent tradition in the field of modern art. The link between these various artists does not exist on the level of shared principle, as with the avant-garde groups of the Modern Movement and the present day. Indeed Michael Andrews shows himself suspicious of any desire to set out artistic principles in written

form, regarding his own published notes as 'a capitulation to the anxiety to be entrenched in a certainty of any kind'. One might conclude from this that the only common ground between such artists is a certain view of their role in the world which depends radically on their reaction to the aesthetic revolution of the Romantic movement and the technical revolution of photography. But this leaves out of account the question of personal influence— not the give and take between colleagues who frame a manifesto, but the strictly face to face relationship of teacher and pupil. It is difficult to look at the preoccupations of Auerbach and indeed Michael Andrews without calling to mind the most senior and respected figure associated with the Beaux-Arts group, David Bomberg. Although Bomberg never actually exhibited at the gallery, a retrospective exhibition had been planned for 1958 and was forestalled only by his death. In his last years, his students had included Auerbach.

There are many similarities between the ideas of Bomberg and the two younger British painters. For example, Bomberg's view of draughtsmanship is an essentially exploratory one. He maintains: 'A draughtsman has no opinions about the wrong and the right kind of art. He registers progress by the revaluation of scale in the passage of time.' Michael Andrews echoes the view in his notion of painting as process, concerned with the realization of objectives and not with the satisfaction of objective criteria: one must 'paint . . . beyond the stage of being aware of it as good or bad'. It would perhaps be justifiable to take the work of Bomberg, the one-time Vorticist, as another example of the 'destructive' procedure. Certainly this interpretation is supported by his astonishing *Self-portrait*, which is simultaneously revealed and cancelled by the searing strokes of colour. (47) However there is more interest in closing this section with an example which, as in the two previous chapters, takes the path under consideration to its most extreme. This is the case with the work of another pupil of Bomberg, Gustav Metzger.

Metzger has related that, during his period under Bomberg, he visited the Tate Gallery in the company of his teacher:

He remarked that I was dissatisfied with painting and asked what sort of painting I was after. I was unable to give a coherent answer. All I knew was that it had to be extremely fast and intense. About ten years later I saw Pollock's drip paintings. They came nearest to that conception of painting I had in 1946.

Despite this passage, it is not difficult to record a debt to Bomberg as well as a kinship with Pollock in the series of works which Metzger began around 1957. His gestural marks are not far from the broad exploratory use of line characteristic of his teacher. Where Metzger departs from Bomberg, and ultimately from Pollock too, is in the abandonment of a figurative scheme, followed by an abandonment of the traditional materials of painting. Already in 1958, Metzger had completed a series of works on

mild steel. The material applied was still pigment, but the palette knife which was used to apply it was also employed to 'scrape and incise' the steel. Traces of white chalk, which the artist knew and intended to be impermanent, were also added in one case. (41)

In 1960, Metzger finally succeeded in capturing the 'fast, intense vision' which he had been searching for. His technique substituted acid and nylon sheeting for the traditional combination of pigment and canvas. The nylon was stretched over a rectangular wooden frame, which served the purpose of the conventional stretcher. The acid was originally applied with a brush, although at a later stage a form of mechanical spray was substituted. Obviously the strokes of acid did not merely modify the surface of the nylon ground. They immediately began to rot the stretched material, causing gashes and rents to appear in it. Metzger was therefore obliged to convert the act of painting into a kind of performance, at which the audience participated in every stage of the creative/destructive process. (42)

It is interesting to relate Metzger's procedure to the chief themes of this chapter, and to the artists whose work has already been discussed. In the first place, there is a completely new significance for the idea of 'experiment'. The artist is not simply testing reality, and his perception of reality, through the intermediary of a painterly technique. He is embarked upon a process of discovery which involves actual experiment, in the scientific sense, with chemical substances that have never entered the painter's repertoire before. Metzger envisages the future of his 'auto-destructive' art as an extension of the relatively simple chemical procedures which he utilized at the start:

The artist works with specialist consultants at the design stage. The order for the work is eventually given to a factory where it is produced. The artist makes the original outline plans and supervises the development at all stages.

With the artist in control of modern technological processes the notion of experiment has clearly acquired a new force. But it is equally clear that the resultant product will no longer be seen within the context of painting. The larger projects which Metzger hopes to be able to carry out at some stage are all sculptural, in the sense that they require some measure of three-dimensional stability to fulfil their public role. One such project, which was based on the technical advice of an expert from the National Chemical Laboratory, involves three large slabs of highly polished mild steel 1/8-inch thick. When these are exposed to the corrosion of an industrial atmosphere, they decay over a period of about ten years. The similarity to the decay of the taut nylon sheet is obvious, but the monumentality of the original scheme and the vastly extended time-scale put it into an entirely different category. (44)

None the less, if we confine ourselves to Metzger's two-dimensional works, the temptation to regard these as the ultimate aesthetic expression of the path of destruction is overwhelming.

In the paintings with acid on nylon, the artist destroys the work
in the process of creating it. There is a fascinating tension between
the development of the forms to their fullest extent—their creative
flowering—and the inevitable progress of the work towards des-
truction. The principle is even more brilliantly demonstrated in
the case of certain crystalline substances which Metzger displays
through slide projection. 'In the course of heating material to
the point of disintegration,' he writes, 'forms and colours are
achieved that lie outside the range of previous art forms.'

The cardinal difference between this process and the attitudes
which have been discussed previously lies, of course, in the complete
transfer of destructive energy from the artist to the material. The
artist no longer needs to 'twist himself'—to delve into his own
psychology—in order to release the destructive forces. He simply
allows himself to be the channel through which these destructive
forces are communicated to the public. And though the possibili-
ties of self-knowledge, and perhaps of artistic fulfilment, may be
somewhat limited by the automatism of the creative/destructive
element, the possibility of objectifying and holding out to public
witness the phenomenon of destruction more than compensates for
this in the view of Metzger. Both Giacometti and Metzger see the
continued activity, rather than the individual work, as all-im-
portant. Yet if Giacometti is inclined to see this activity as a self-
justifying process without any conceivable goal, Metzger never
loses sight of the possibility of transforming social attitudes
through an aesthetic of 'revulsion'. Indeed this additional dimen-
sion in Metzger's work effectively reverses the categories which
we have been using, for the final purpose of auto-destructive art
is to become 'a constructive force in society'. The 'curtains' which
Giacometti tears away can never reveal the reality that lies behind.
In Metzger's South Bank demonstration of 1961, however, the
flapping shreds of nylon drew apart to reveal a prospect of St Paul's
and the City. (43)

5 Paths of experiment: reduction

Up to this point my study has only considered American art in one of its least characteristic and least well-known aspects—the reliefs of Charles Biederman. This ensuing chapter will be concerned almost exclusively with the work of three celebrated painters of the New York school: Jasper Johns, Robert Rauschenberg and James Rosenquist. But, in order to justify my selection of this group, I must clarify a number of points about the general context of American painting. These will be raised once again at the conclusion of my study.

It might be argued that in any survey of 'Experimental painting' undertaken in 1969 the triumphs of American post-war painting should be given pride of place. My own concern with tracing a number of lines from the Modern Movement and the nineteenth century might be seen as an anachronism in a world which is acquainted with Pollock, De Kooning and Barnett Newman. Yet this possible accusation would only hold if the notion of experimental painting were held to be synonymous with excellent, new and influential painting. My own inclination would be to concede all these adjectives, while remaining adamant on the question of experiment.

There would be little sense in trying to extract an absolutely specific notion of experiment in painting from the numerous cases which have already been given. As I suggested in my initial chapter, experiment or research in its pure form has tended to militate against the viability of painting as a separate genre of the visual arts. The painters in my subsequent sections are not pure experimentalists, if only because their direction is determined by a dominant principle which cannot be justified in purely experimental terms. But they share the desire to view painting as an activity which has no specific goal, yet is none the less liable to certain specific controls. In the case of Vasarely and the Groupe de Recherche d'Art Visuel, these are primarily the self-imposed controls of the clearly formulated personal manifesto and the communal criticism. In the case of Giacometti and Auerbach, they are the controls imposed by the external world, which perpetually eludes discovery. In each case, the painter is engaged in *testing* his work against this external constraint. His 'experimental' procedure is designed to realize the stated objectives, or capture the given appearances, one at a time.

In the case of the American painters who have been mentioned, these features do not apply. Robert Motherwell has identified the quality of 'venturesomeness' as the supreme ethical value represented by the Action painters and their successors. But 'venturesomeness' is very different from experiment: it emphasizes the individual act of commitment rather than the adoption of external criteria which may limit the authenticity of that act. When Jules Olitski pointed out to Anthony Caro that the single rod in space could be a sufficient sculptural statement, he was certainly

challenging him to extend his artistic vocabulary. But if any experiment was involved, it was an experiment which Caro had to carry out upon his own personal proclivities. The rod existed, as a potential element in some future sculpture, and Olitski's role was simply to transform Caro's attitude from a conventional to an adventurous one.

Another illustration of the way in which the American artist has moved away from the principle of external controls, which alone makes sense of the idea of artistic experiment, is provided in a recent review of the work of Frank Stella. The American art historian Joseph Masheck writes, with reference to Stella and Frank Lloyd Wright:

You start by confining yourself to a piece of graph paper, a straight edge, a 30°—60°—90° triangle, and a compass, but then—and this is where Wright left the Ecole des Beaux Arts and the whole European mind behind in the dust—you just *tinker*. If, like Wright or Stella, you tinker intelligently, you get beauty.

By contrast to this, we might invoke the case of a strictly European painter such as Vasarely, who leaves the evidence of the triangle and the compass precisely so that the spectator may sense the impersonal, geometrical basis of the work. For Vasarely, communication takes place on a level akin to that of traditional classicism: the elements of the work are distinct and identifiable, even though the work as a whole is composite and unpredictable. For Stella, the entire notion of classicism is a foreign one: there is no intention of engaging the spectator's attention on these two complementary levels.

The example of Frank Stella holds another point of interest in relation to experimental painting. Like many of the artists whose work has already been discussed, he paints almost exclusively in series, and prefers each series to be exhibited as a whole at least once. Does this similarity qualify him as an experimentalist? In the answer to this question lies much of the argument for the distinctive status of American painting. In a radio interview with David Sylvester, Stella underlined the fact that he himself, and the rest of his generation, had accepted the heritage of the European masters—in his case Mondrian and Malevich—while totally rejecting their metaphysics. He suggested that the present generation of American painters was engaged in exploring the pictorial problems which had been posed in the early part of the century, but had no desire and no need to relate them to the world of nature or the world of the mind.

This complete rejection of the 'beyond', whether on the physical or the metaphysical level, puts American painting on the level of syntactic variation, rather than experimentalism, since the latter can only have meaning if there is some external standard governing the experiment. Even the simple schema of abstraction from the natural world, which is accepted by a contemporary painter like Vasarely, has virtually no place in America, which took over abstraction as a *language* rather than a *process*.

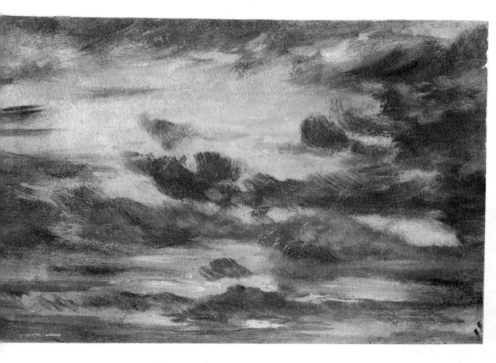

1 JOHN CONSTABLE Cloud Study c. 1822
Fitzwilliam Museum, Cambridge

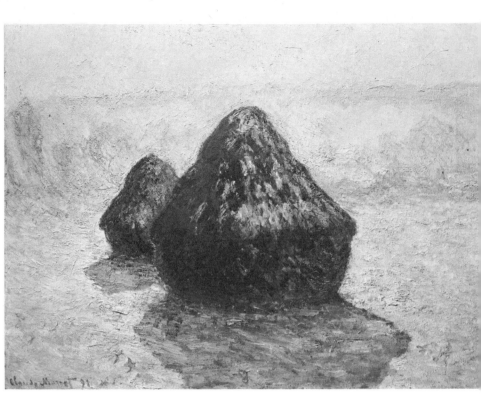

2 CLAUDE MONET Haystacks *National Galleries of Scotland*

3 LASZLO MOHOLY-NAGY Kupferbild 1937 *Marlborough Fine Art, London*

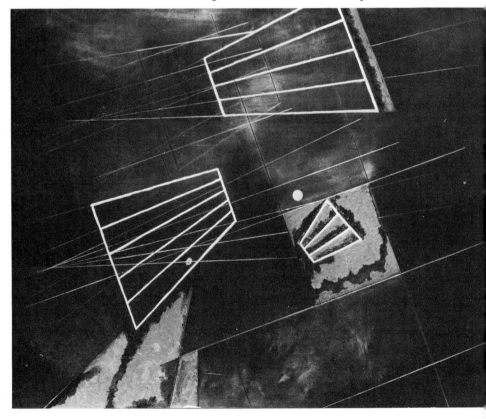

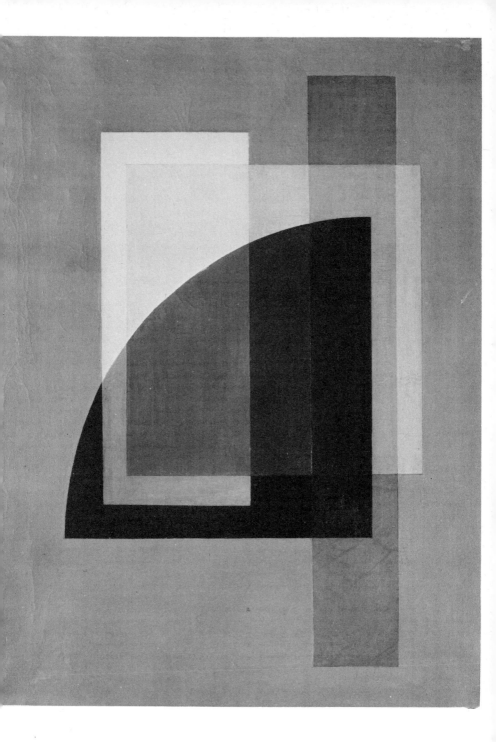

4 LASZLO MOHOLY-NAGY Schwarzes Kreisviertel mit roten Streifen 1921
Marlborough Fine Art, London

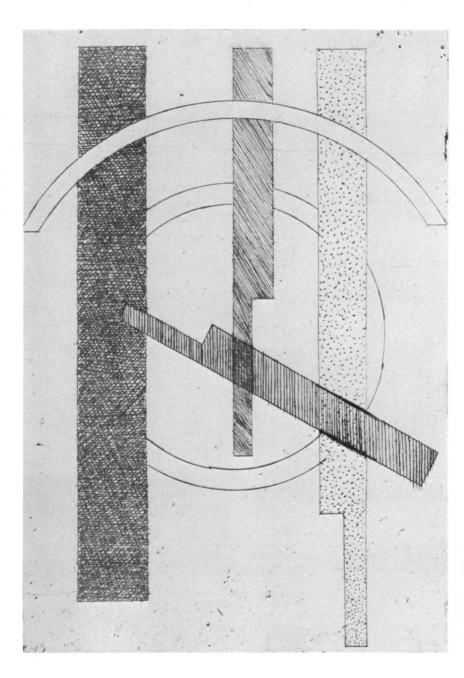

5 LASZLO MOHOLY-NAGY Konstruktivistisch 1925
Marlborough Fine Art, London

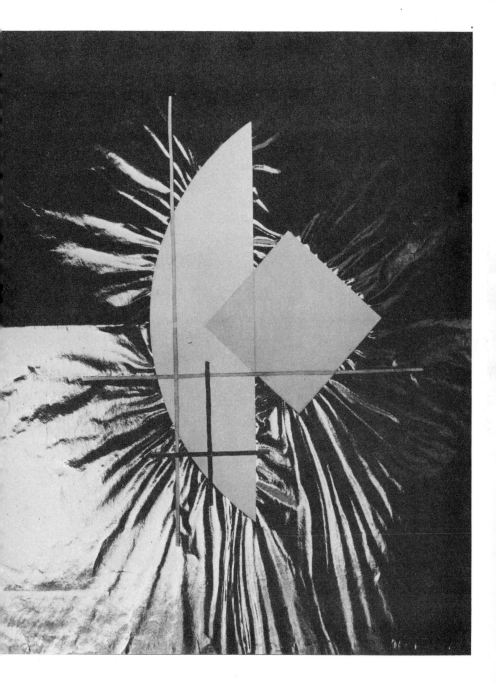

6 LASZLO MOHOLY-NAGY Blaues Segment und rotes Kreuz 1926
Marlborough Fine Art, London

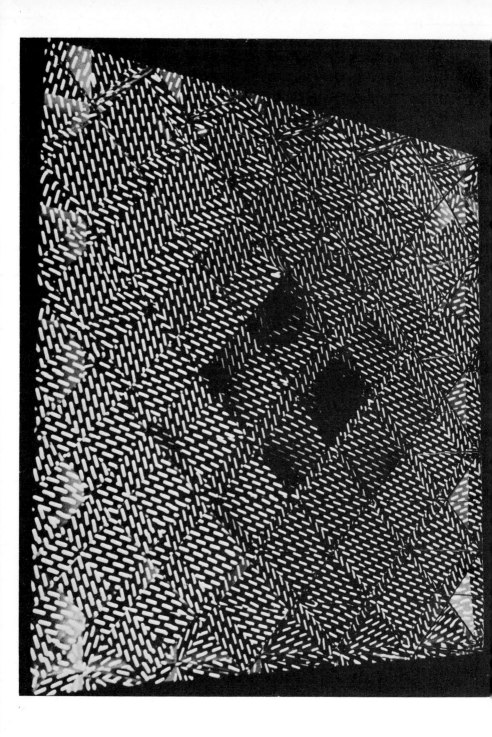

7 MARTHA BOTO Labyrinthe au Carré 1966

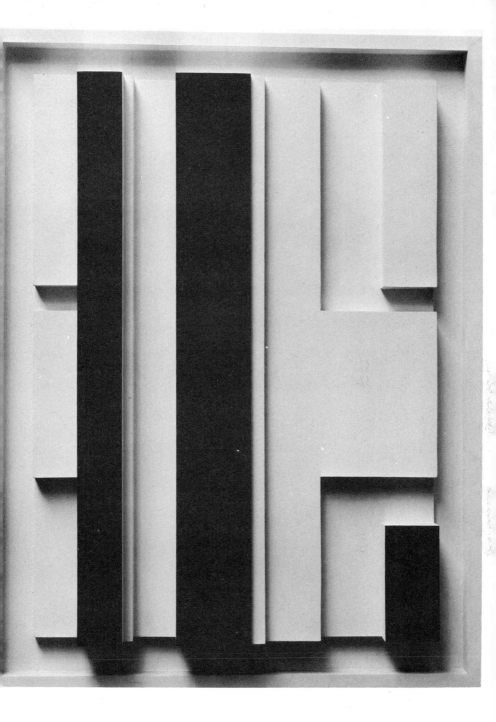

8 CHARLES BIEDERMAN Structurist Work 1938
Photo: Bernard Dordick

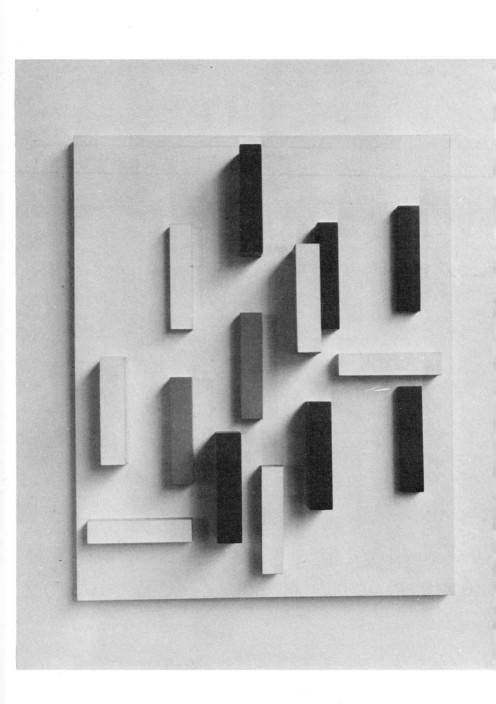

9 CHARLES BIEDERMAN Teaching model 1951–2

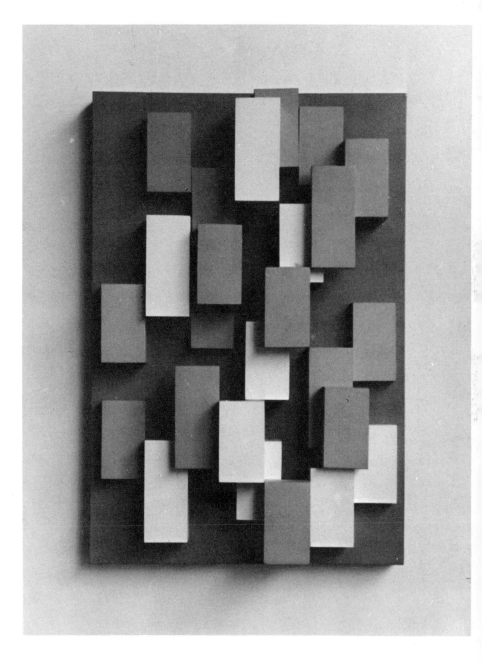

10 CHARLES BIEDERMAN Teaching model 1951-2

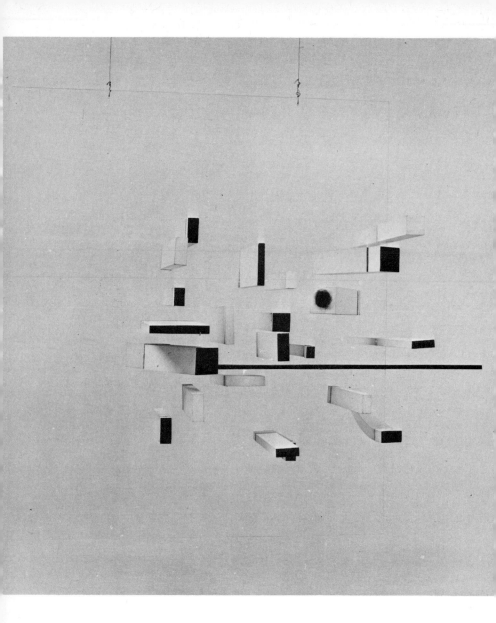

11　VICTOR PASMORE　Transparent Hanging Construction in White,
Black, Maroon, Green and Pink　*Photo: John Pasmore*

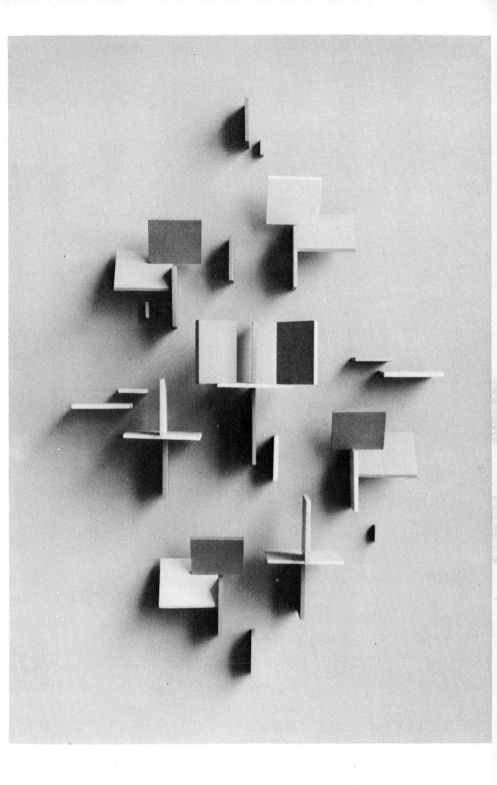

12 CHARLES BIEDERMAN Structurist Work (model) no 7 1968

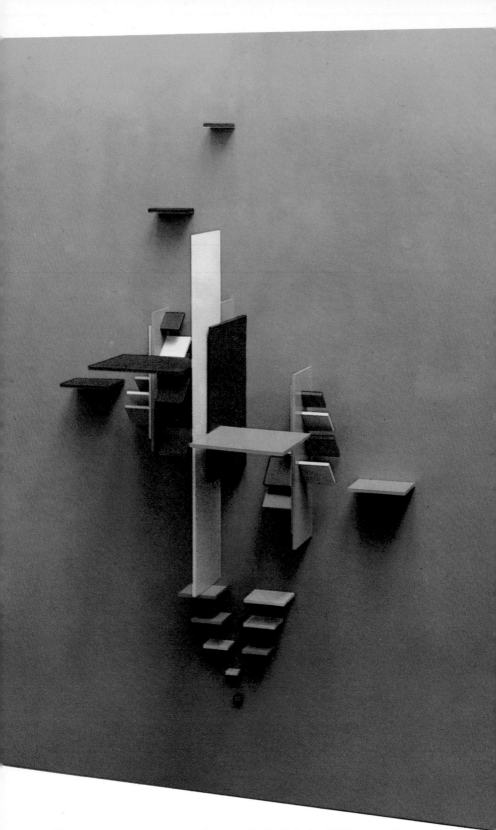

13 CHARLES BIEDERMAN Structurist Relief: Red Wing no 45
1962–5

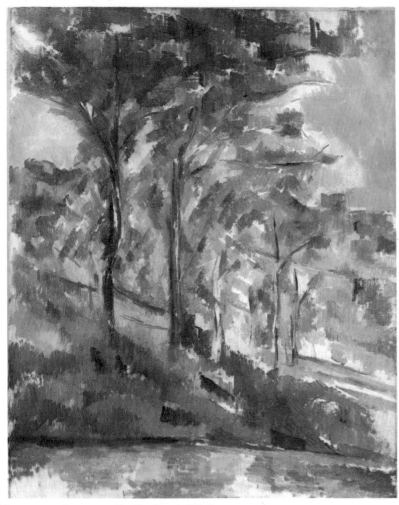

14 PAUL CÉZANNE La Forêt 1882–5
Fitzwilliam Museum, Cambridge

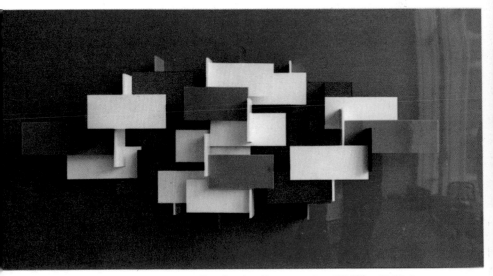

15 JOOST BALJEU Synthesist Construction W XI 1960–9
William Schöningh, Switzerland

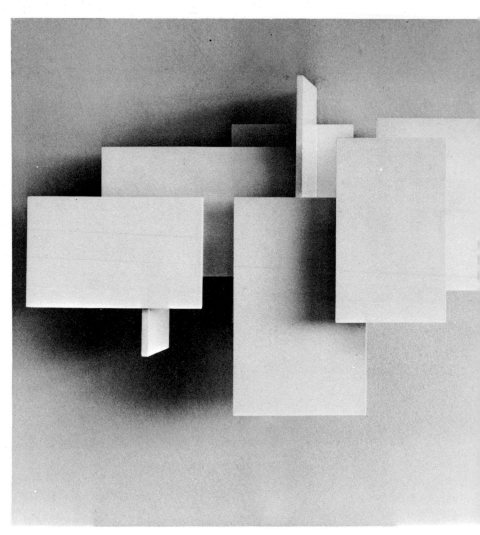

16　JOOST BALJEU　Synthesist Construction W I　1957-67
Jac. ten Broek, Amsterdam

17　JOOST BALJEU　Synthesist Construction A III (One family home)
Jac. ten Broek, Amsterdam

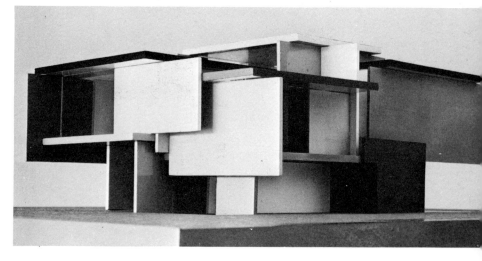

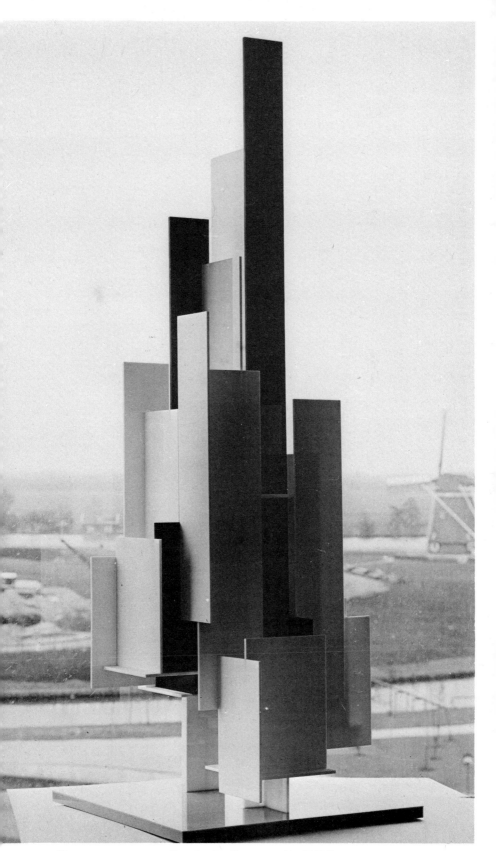

18 JOOST BALJEU Synthesist Construction F IV 1966–8
Dutch Government

19 VICTOR VASARELY Belle-Isle 1947-52

20 VICTOR VASARELY Folklore Planétaire 1964

21 VICTOR VASARELY Pyramidal Relief 1964

22 VICTOR VASARELY Relief 1968

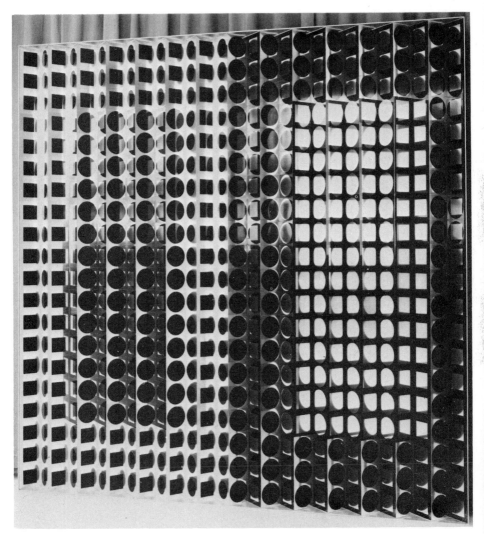

23 FRANÇOIS MORELLET Simples Trames 1958-9

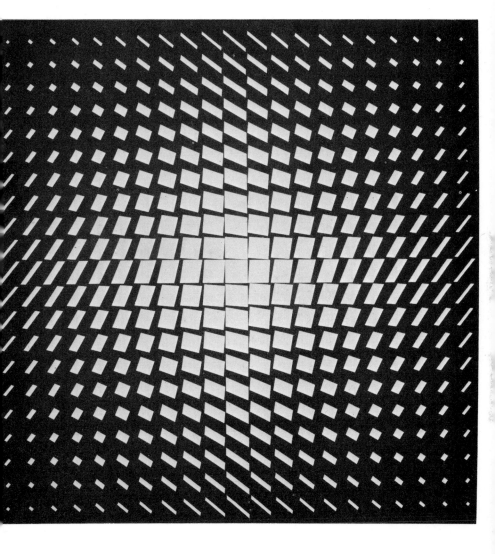

24 ᴠᴠᴀʀᴀʟ Variation sur le Carré 1967 *Photo: André Morain*

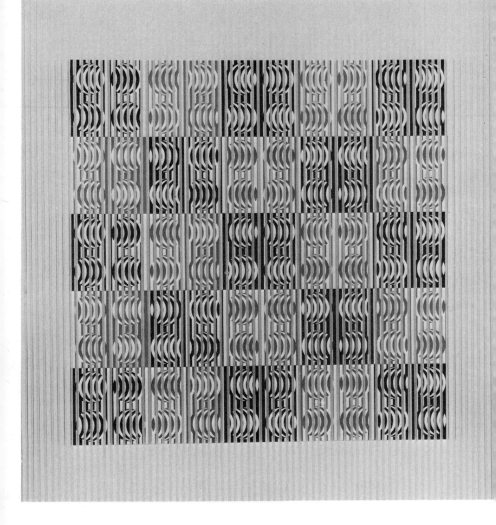

25 YVARAL Accélération Optique 1968
Photo: André Morain

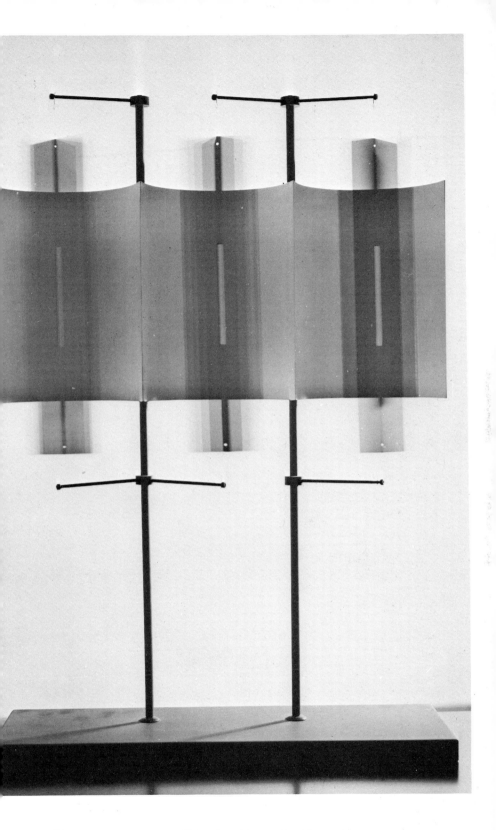

26 BERNARD LASSUS Brise-Lumière no 2 1959–62
Studio Martin, Paris

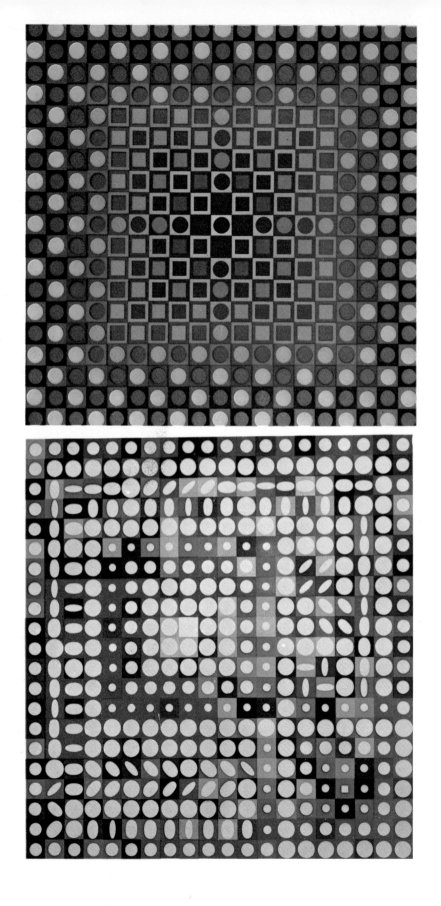

27 VICTOR VASARELY Folklore Planétaire 1962

28 VICTOR VASARELY Permutation 1966

29 YVARAL Structure Ambigüe 1969
 Photo: André Morain

30 BERNARD LASSUS Ambiance 14 (detail) 1967 Plan above

31 BERNARD LASSUS Ambiance 10 (detail) 1965–6

32 BERNARD LASSUS Ceiling, Lycée de St Avold

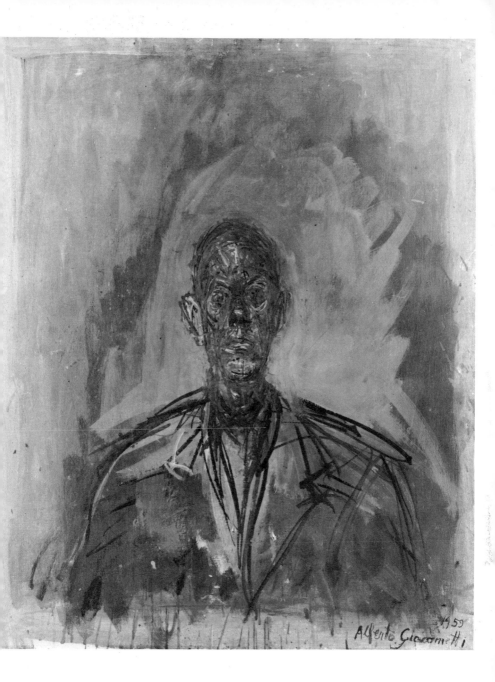

33 ALBERTO GIACOMETTI Diego
Tate Gallery, London

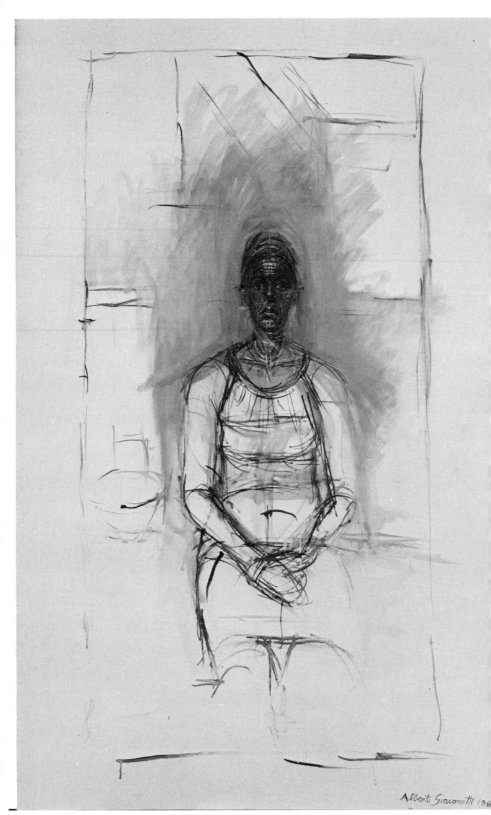

34 ALBERTO GIACOMETTI Caroline 1965
Tate Gallery, London

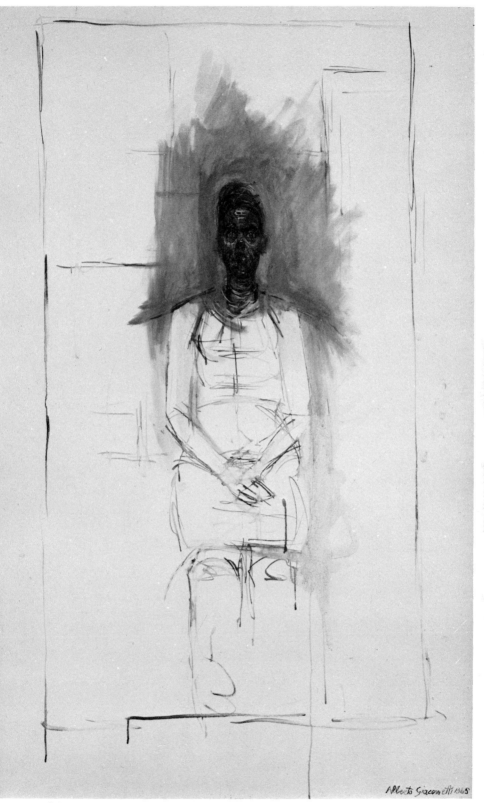

35 ALBERTO GIACOMETTI Caroline 1965
Tate Gallery, London

36 FRANK AUERBACH two studies for The Sitting Room 1963–4
Marlborough Fine Art, London

37 FRANK AUERBACH E.O.W. Sleeping II 1966
Marlborough Fine Art, London
38 FRANK AUERBACH Primrose Hill, Summer 1968
Marlborough Fine Art, London

39 FRANK AUERBACH Figure on a Bed 1966
Marlborough Fine Art

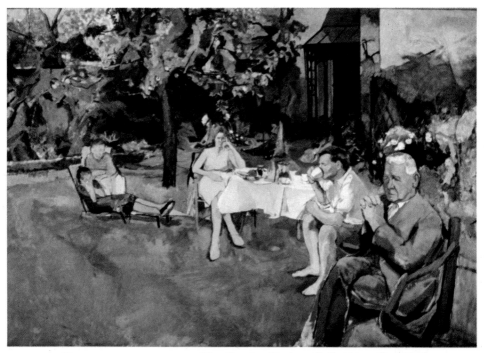

40 MICHAEL ANDREWS The Garden Party *Gulbenkian Foundation*

41 GUSTAV METZGER Untitled painting, oil and white chalk on mild
 steel 1958

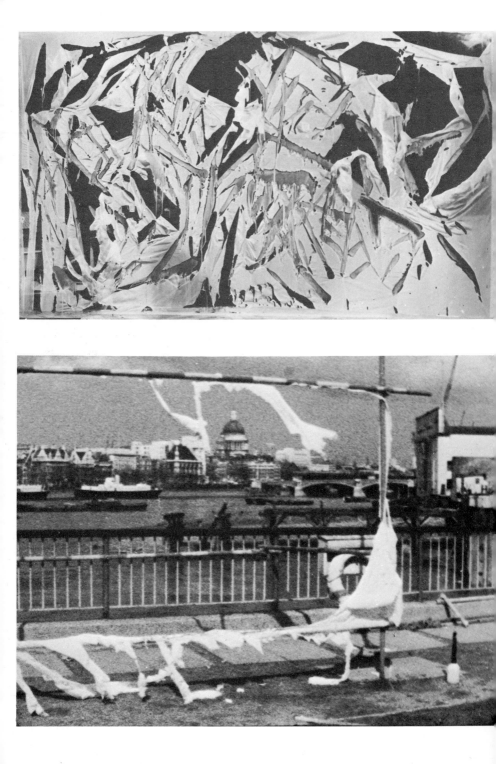

42 GUSTAV METZGER First public demonstration of acid-nylon technique 1960

43 GUSTAV METZGER Final stage of acid painting on nylon (South Bank site, London) 1961

44 GUSTAV METZGER Model for construction in mild steel 1960

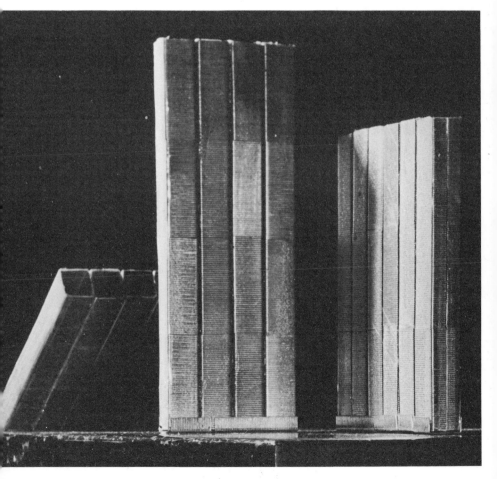

45 JAMES ROSENQUIST Scrab Oak 1968
Galleria Sperone, Turin

46 ROBERT RAUSCHENBERG Revolver 1967
Castelli Gallery, New York

47 DAVID BOMBERG Self-Portrait 1956–7
Mrs Lilian Bomberg

48 JASPER JOHNS According to What 1964
Mr. Edwin Janss Photo: Rudolph Burckhardt

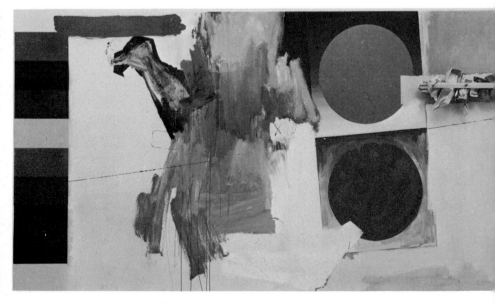

49 JASPER JOHNS Edingsville 1965
Dr Peter Ludwig, Aachen

50 JASPER JOHNS Screen Piece 5 1968
Photo: Rudolph Burckhardt

51 JASPER JOHNS Wall Piece 1968
The artist

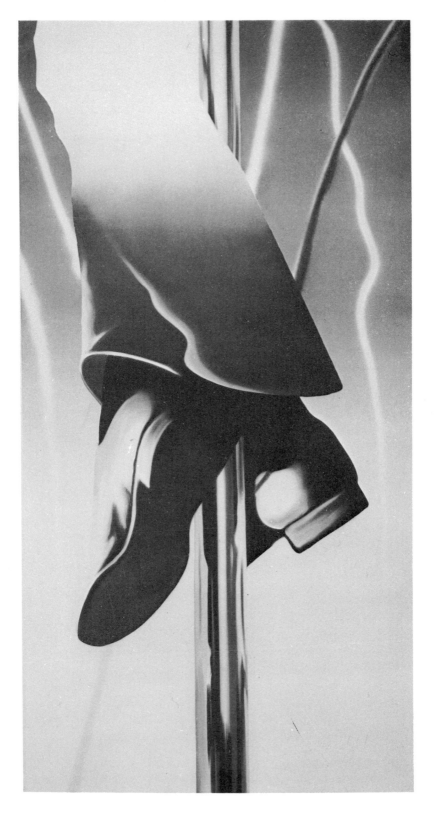

52 JAMES ROSENQUIST Study for Expo 67 1967
Mr and Mrs Robert C. Scull

53 JAMES ROSENQUIST For Lao Tsu 1968
Ileana Sonnabend Gallery, Paris Photo: Parnotte, Boulogne-sur-Seine

54 ROBERT RAUSCHENBERG Bicycle 1963
Photo: Rudolph Burckhardt

55 ROBERT RAUSCHENBERG Solstice 1968
Ileana Sonnabend Gallery, Paris Photo: Shunk-Kender, Paris

56 ROBERT RAUSCHENBERG Soundings
Dr Peter Ludwig, Aachen Photo: Shunk-Kender

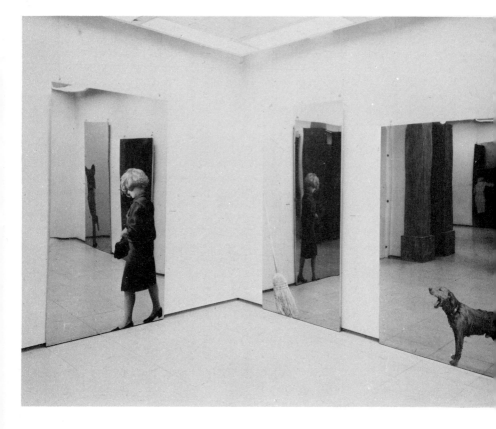

57 PISTOLETTO Vue de l'Exposition 1967
Ileana Sonnabend Photo: André Morain

58 IAN HAMILTON FINLAY Wave/rock 1966
Photo: Patrick Eagar

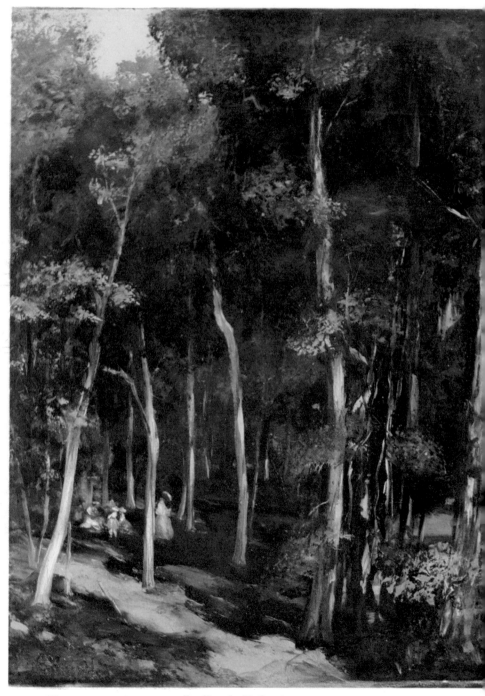

59 GUSTAVE COURBET La Ronde Enfantine
Fitzwilliam Museum, Cambridge

The closest analogy to the procedure of an artist like Stella can therefore be found not in the various types of pictorial experiment reviewed here, but in the literary and linguistic model offered by Roland Barthes. 'The writer is a public experimenter. He varies what he recommences; obstinate and faithless, he knows but one art: that of the theme and variations.' This idea of the variation may seem too limited to do justice to the individuality of the works considered singly. But, as Barthes emphasizes, it is an idea which acquires a new range of meaning when removed from the strictly temporal sequence which it implies: 'in opposition to what happens in music, every one of the variations is taken itself as a solid theme, whose sense is immediate and definitive.'

The three American painters who are to be considered in this chapter—Johns, Rosenquist and Rauschenberg—cannot be regarded as exceptions to the general rule which I have suggested. They are very far indeed from the controlled experiments of the Groupe de Recherche d'Art Visuel, or the constructive artist's continual recourse to the natural world. They are themselves committed to the 'venturesomeness' which was the heritage of Abstract Expressionism, and their work is no less a series of variations on the language of style than that of Stella. But my justification for considering their procedure rather than that of their fellow artists still stands. Their distinctive point is that they are following a direction which can be traced in conceptual terms, and even appears to possess a degree of logical necessity. This is what I have called the 'path of reduction'.

What is this conceptual pattern which exists over and beyond the stylistic and syntactic variations of these painters? The definition is a difficult one, since the 'beyond' against which their works can be measured is not outside the immediate field of art. In effect, their point of departure is the conceptual scheme laid down for the description and elucidation of the new American idiom. Their works constitute a critique and at the same time a 'reduction' of certain basic critical postulates which were used to establish the revolutionary nature of post-war American painting.

It was Harold Rosenberg, in his essay on the Action Painters, who launched the critical debate. Rosenberg asserted that here was a type of painting 'not an object, nor the representation of an object, nor the analysis or impression of it, nor whatever else a painting has ever been.' This statement rapidly provoked an incisive retort from Mary McCarthy: 'You cannot hang an event on the wall, only a picture.' But Miss McCarthy had by no means closed the issue. The debate as to whether American art consisted of pictures or events, paintings or facts, continued to run, and still does run, as the following recent passages from a review by Dore Ashton amply prove:

While it is true that roughly since Cézanne, it is the means of art that have been admired . . . it is not exactly accurate to turn those means into facts . . . The modern interest in the exposure of the painter's means inevitably backs up into the eternal fascination illusion holds

for us, and not into physical facts . . . What is real about [Morris] Louis' so-called 'unfurleds' is not the raw canvas or their 'physical existence as space-occupying objects' but their vast and compelling illusion. Those coulisses of bright colours at the extreme edges define the nature of the experience; they are dynamic proposals that we enter the infinite breadth of the central void; that we share in an exquisite spatial experience the artist had which was real, and at the same time, conveyed in the only terms possible, illusion.'

For the critic, this assertion of the traditional terms of reference may appear inevitable. But for the painter the question of whether a painting is a physical fact, and, if so, what kind of fact, may provide a fertile field of assumptions to be tested within the course of his artistic activity. This has been exactly the case with Johns, Rauschenberg and Rosenquist, whose early development as painters took place in a milieu profoundly affected by Rosenberg's vindication of action painting. But while the critical equation could be made once and for all, the painter was forced to reopen the enquiry on his own terms. The question was posed: if the painting is a fact or event, what kind of fact or event is it? Common sense might reply that it is a plane surface, that it is more than a plane surface, or that it is a substitute for a section of wall. Precisely similar answers have been found by the three painters under review, but only as a result of a rigid process of reduction, in which the contingent and inessential features of the work have been progressively pared away.

JASPER JOHNS

The late Frank O'Hara once wrote of his friend Franz Kline: 'If painting was a wall to him, as several of his titles indicate, it was a wall upon which he, as the Mime, would appear in full to reveal the secret of the Dream. . . .' If Kline 'appears in full' upon the wall of the canvas, Jasper Johns is involved in a problem directly antithetical to that of the older painter. It is not the canvas as wall, but the extent to which the canvas, while lying so close to the wall, *cannot* be a wall that preoccupies him. He is concerned with the painting as substitute.

However this is to anticipate the final stage of my argument. Several previous stages must be covered before this ultimate point becomes comprehensible. Two excellent essays, by Alan R. Solomons and Rosalind Krauss, have already been devoted to Johns' career as a painter, and it is not my intention simply to retrace the ground which they have covered. I shall discuss a number of works dating from after 1962, and in particular a group from 1967-8, which are subsequent to the two essays previously mentioned.

To begin in the 1960s is not an arbitrary choice. Alan R. Solomons has drawn attention to the 'systematic attitude which underlies [Johns'] procedure', and he has a convincing division between the various phases that mark the development of the

system. Johns deliberately suppressed all the work which ante-dated his first *Flag*, completed in 1955. From 1955 to 1958 he started to use as his characteristic subjects 'flags, targets, numbers and letters, and objects covered with paint'. From 1959 to 1962, his work became 'more abstract and more expressionistically painted', while retaining the words, letters and numbers of the earlier period: at this stage he also ventured upon his series of maps.

The great majority of these works concentrate upon ambiguities of surface and subject, which occur in their most direct form in the *Flag* series. But as early as 1959 the surface is broken up by the incorporation of real objects—rulers, wire-suspended forks, spoons and so on. By 1961 this element is so dominant that Solomons can refer to Johns' concern with a 'vocabulary of object conditions'. By 1962 it is the central theme of his work.

Between 1959 and 1962, therefore, there is a dovetailing of two separate stylistic procedures in Johns' painting. A new itinerary is begun, but this emerges gradually from the old. How can the broad difference between the two be identified? In part, this can be done in Solomons' terms. Johns began his career as a painter with the brilliant equivocation of the flag series, where the 'object' depicted was indistinguishable from the pictorial surface. Subse-quently he moved away from the given, if problematic, subject to a point which John Cage has analysed effectively: 'Finally, with nothing in it to grasp, the work is weather, an atmosphere that is heavy rather than light (something he knows and regrets); in oscillation with it we tend toward our ultimate place: zero, grey disinterest.' Up to the early 1960s, in other words, Johns tended towards a vacuum, from which the subject had been excluded. But as early as 1959, objects or 'object conditions' had begun to invade this vacuity.

However it is impossible to appreciate the significance of this change without referring to the work of another artist. As Rosa-lind Krauss had recorded, Johns came into contact with the 'art and personality' of Marcel Duchamp late in 1958. The catalytic effect of this influence is apparent if we examine the transforma-tion in Johns' work between 1958 and 1964 in the light of Du-champ's theories.

Perhaps the most reliable guide to Duchamp's artistic procedure is the series of working notes included in the so-called 'Green Box', which were published in an English version in 1960 and mentioned by Johns in an article on Duchamp later in the same year. Items from these notes, taken virtually at random, have interesting implications for the art of painting. Almost at the beginning, for instance, Duchamp suggests a 'kind of Sub-Title' for the 'Bride stripped bare by her bachelors, even': it is to be called a 'Delay in glass'.

It's merely a way of succeeding in no longer thinking that the thing in question is a picture—to make a 'delay' of it in the most general way possible, not so much in the different meanings in which 'delay' can be

taken, but rather in their indecisive reunion 'delay'—a 'delay in glass' as you would say a 'poem in prose' or 'a spittoon in silver'.

Two separate meanings can be extracted from this purposefully obscure formulation. The work is a 'delay' both in the sense that it retains the attention of the spectator, and in the sense that it retains the images or objects incorporated into it. The second point applies particularly to the 'Bride', since the elements of which it consists are trapped between two surfaces of glass. They may, like the exquisite water-wheel, offer an illusion of perspectival space. But this is cancelled almost immediately by the fact that we are aware of the exact thickness of the transparent picture plane. Duchamp emphasizes the highly precarious quality of the plane surface once the apparently limitless density of the canvas is replaced by a medium that is transparent. Though the glass succeeds in 'delaying' the cluster of objects and images, we are conscious of their tendency to disperse into the space which clearly manifests itself beyond.

A second illustration from Duchamp's 'Green Box' can be found in a note dated September 1915:

With a kind of comb, by using the space between the two teeth as a unit, determine the relations between the 2 ends of the comb and some intermediary points (by the broken teeth). Use, as a proportional control, this comb with broken teeth, on another object made up, also of smaller elements.

The problem which Duchamp is tackling here is the particular question of the status of the object. He proposes to make use of a type of object which posits a dual scale of proportions. In the first place, the comb belongs within our world for conventional measurements. Even when incorporated in the art work, it is entirely familiar. But at the same time, within the closed system of the art work, it can become an absolute graduated scale, or 'proportional control', for another object that belongs exclusively to the representational context. It functions as a kind of medium term, at once a vestige of our world and an indication of the relativity of all measurement within the world of the work of art.

My last quotation from the 'Green Box' comes from the very end, and in fact appears as a 'Musical Erratum'. Yvonne, Magdalenie and Marcel sing in turn: 'To make an imprint mark with lines a figure on a surface impress a seal on wax.' The implication is that an object can leave its 'trace' on the work even if it is not actually represented or incorporated. And any such trace involves a kind of transaction between object and surface, whether directly (seal on wax) or schematically (line on surface) conveyed.

The course of Johns' work from 1960 onwards provides many parallels to the notions advanced in the 'Green Box', and exemplified in such works as the 'Bride' itself and *Tu m'* (1918). For example, the motif of the object which acts as a 'proportional control' between the scale of the picture and the scale of the surrounding world is a recurrent one. As early as 1960, in *Painting*

with Ruler and Gray, Johns was using the ruler, with its graduated divisions, to make this point. By 1961, with *Good Time Charley,* the ruler has been conflated with another characteristic motif, the 'device' or stick of wood anchored to the centre of the picture and covering the sweep of the surface like the hand of a clock. In other words, it is no longer simply in one dimension that the picture area is 'measured': the implied sweep of the ruler covers a large proportion of the canvas, leaving as a trace of its passage the visible slurring of the pigment. In *Out the Window* (1962), the extreme edge of this area is inscribed with the word 'Scrape', between arrows that point in both directions.

So we return to Duchamp's notion of the 'trace'. The ruler or device is not merely an object in its own right. It is also conveyed to us through the visible evidence of the path which it has taken at a previous point. Johns himself has defined his attitude to the problem of the imprint or trace in the following significant passage:

An object that tells of the loss, destruction, disappearance of objects. Does not speak of itself. Tells of others. Will it include them? Deluge.

The influence of Duchamp's metaphysical questioning is apparent here. But there is also a clear indication of the path which Johns has followed over the past few years. The first 'object' is, of course, the work of art itself. The question—'will it include them?'—is the vital question which Johns has posed to himself, with increasing urgency, over the years between 1964 and 1968.

Let us consider first of all a work which has a crucial place in this development, the celebrated *According to What* of 1964. This is a much larger painting than its predecessors, and by this same token raises the issue of 'inclusiveness' in an acute form: 'Will it include' the heterogeneous collection of elements which are amassed in, on, and in relation to the picture plane? At the same time the title of the work directly raises the problem of measurement which was touched on earlier. 'According to what' criteria can we operate the transition from the surrounding world to the particular world of the picture? (48)

Comparisons have been made between Duchamp's last oil painting, *Tu m'*, and *According to What*. At first sight, Johns' work has the same appearance of an anthology of varying styles and personal motifs loosely assembled. His graduated range of colours, in the very centre of the picture, directly recalls the lozenge-shaped colour samples in *Tu m'*. Yet there is a great difference in conception between the two works. Duchamp provides a kind of anthology of pictorial themes, just as, in more recent years, he has published collective editions of miniaturized ready-mades. He was in fact closing a chapter in his career, since there was an entirely conscious decision to make this his last painting. For Johns, on the other hand, the situation is almost reversed. *According to What* is the point of departure for his most systematic and cogent exploration of the painting as work of art.

Two motifs in the picture are particularly interesting in relation to Johns' previous and subsequent work. At the top left-hand corner, there is an inverted chair, whose two nearest legs have been cut away. In the bottom right-hand corner, a mangled wire hanger is affixed. The latter object recalls the series of utilitarian articles—forks and spoons in particular—which Johns was introducing as early as 1961. If forks and spoons are themselves utensils—objects serving a simple functional purpose—the wire hanger is a *reductio ad absurdum* of the useful object. Itself reduced from the traditional wooden hanger, it represents the barest possible vestige of a load-bearing frame.

The mangled chair has a rather different significance. In the first place, it is related by implication to the seated human form, while the hanger is merely a device for preserving human clothing. This relationship is oddly emphasized by the presence of a schematic form in the shape of a human leg and thigh which adheres to the chair and the canvas. Johns has returned to this motif of the inverted chair and fragmented human form on at least one other occasion. It is perhaps the most emotive 'trace' that he has permitted himself, and perhaps only avoids banality because the whole motif is inverted and therefore removed from our immediate area of spatial reference.

If we compare *According to What* with a picture from the following year, *Edingsville* (1965), a new pattern of motifs becomes apparent. The work is smaller than its predecessor, though still large in comparison with Johns' earlier works. Two of the circles inscribed within squares that appeared in *According to What* are retained. But Johns enlarges them considerably, almost as though this were a detail of the previous work. The inverted leg is present only as a roughly indicated area of pigment, the chair not at all. Most interesting of all, the unanswered question, 'According to what', seems to have been resolved by the admission of a strict criterion—once again in the form of a ruler. But the ruler is no longer used sweepingly, over a wide arc of paintwork. It spans a cluster of heterogeneous objects—a fork, tins and an ice-box—that are strung in serried order behind it. If the roughly indicated leg offers the trace of humanity reduced to an almost indecipherable level, the group of battered objects seems to testify to the impossibility of assimilating, 'including', the object. The ruler stands guard over these fragments of the everyday scene, as though they resisted conversion into the imaginary measurements of the pictorial world. (49)

At this point we can take stock of the general direction in which Johns' work was moving in 1964-5. Rosalind Krauss has recorded that by this stage he was dissatisfied by his early paintings, which he felt to be 'too obvious and direct'. She adds: 'And it is indeed in the direction of complexity and difficulty that Johns has been moving especially since 1961.' This comment applies, of course, to the sequence of works up to and including 1964, when Johns' manipulation of the 'vocabulary of object conditions' reached a

high point of complexity. But it cannot hold beyond this date. The richness of content which was apparent in *According to What*, and even *Edingsville*, underwent a rapid process of reduction, the initial stage of which can be observed in the comparison of these two pictures.

In order to grasp the full significance of this process, we must return to Duchamp's conception of the 'delay in glass'—a term which draws attention to the precarious nature of the plane surface in the visual arts. Although Johns does not make use of transparent materials like Duchamp, he is articulating just the same crisis of surface. The cluster of objects in *Edingsville* suggests that he is no longer able to accept the traditional mode of representation, according to which the illusory object is assimilated, or sucked in, by the limitless density of the opaque canvas. But if the canvas is not to operate on this level, how can it operate at all? If the object that is the picture cannot include objects, what alibi must it assume in order to express precisely this inability?

The answer to this question lies in a development of Johns' style which could perhaps have been anticipated as early as 1964, when he painted *The Studio*. In this work the motif of clustering objects appears in a somewhat more primitive form. But the dominant element is a large door, at a slight angle to the canvas, which is constituted partly by the traces of a door on the canvas, and partly by an actual wooden projection from the lower part of the picture. It is extremely noticeable that the painted surface which surrounds this door is not vigorously worked with the Expressionist brushmarks that were a feature of Johns' earlier paintings. In fact, a large part of it is matt, and an area of patterning on the left seems to have been imprinted by contact with some material. The conclusion that might be drawn from this picture is that Johns' alibi will be the wall.

My implication is that Johns' paintings have diverged further and further from a painterly, Expressionist facture where more or less anything may happen. By approaching a stage at which all incidents of the painted surface can be equated with the haphazard drips and washes of an unfinished wall, he succeeds in stepping through the 'delay in glass' which Duchamp had erected. Only in this way can he assume a faint residual power of retaining the vanishing 'traces'. Painting is now a wall to him, as it was to Kline. But it is not a wall upon which he can 'appear in full'. On the contrary, he must eliminate himself, so that *we* are conscious of the extremity of his solution.

The recent works of Jasper Johns can therefore be seen as an extreme attempt to retrieve from the 'deluge' the few basic positions without which representation can have no meaning. In *Screen Piece 5.* the process is almost at an end. The spoon and fork do not dangle from a thin wire, as in several earlier works. Instead they are conveyed—the wire also—through the marks that they might have made on the surface. The surrounding paintwork is almost devoid of the personal facture that we associate with Johns.

Perhaps it is only the flurry of paint in the bottom left-hand corner, and the group of swift downward strokes by the bowl of the spoon that raise the question of authorship to our mind. (50)

Screen Piece gives place to *Wall Piece*. The process is as near complete as we can imagine. Most of the area of canvas appears to have been 'painted' through the application of woven materials that have left small ridges when lifted away. The general texture is close to that of untreated plaster, though the central section is distinguished by a kind of overall patterning curiously reminiscent of Roman mural painting. Finally, in the left-hand section, there is the trace of the eternal fork, with spoon almost obliterated—or rather inadequately imprinted. There is an ultimate irony in the crudely drawn letters that lie adjacent. 'Fork should be 7″ long.' The need to measure the objects in the painting by our own yardstick is asserted, yet by that very token becomes null. And so the campaign is won. (51)

JAMES ROSENQUIST

In his essay on the work of Jasper Johns, Alan R. Solomons speaks of the characteristic attitude which Johns adopts to the 'problem of identity in objects' and the 'relationship between the painted image and the "real" image'. He goes on to make the following claim:

The clarity of the confrontation with these issues in the work of Jasper Johns, and the explicit statement of the philosophical position which underlies his attitude towards them, open the way for younger artists like Warhol, Wesselman, Lichtenstein, Dine and Oldenburg, and in a quite literal sense make their position tenable, since one might say that he gives the permission for the wholesale re-examination of the character and behaviour of objects and images on which the new art is essentially based.

I would entirely concur with this view that Johns, with Rauschenberg, whom Solomons mentions in the same connexion, is at the very source of the complex movement which is loosely equated with American Pop art. My justification for omitting any consideration of the artists mentioned above is that their investigations, however searching, do seem to depend ultimately on the 'permission' of Johns. At any rate, they do not represent an experimental venture to the very limits of painting, as Johns' work does, according to the argument which I have traced. Yet, in addition to Rauschenberg, whose work will be considered in the closing section of this chapter, there is at least one important name missing from Solomons' list, perhaps significantly so. James Rosenquist, who belongs to the second generation of Pop painters like the others in the list, has pursued what is in my view an independent venture comparable to that of the two senior artists. Like Johns, he has adopted a path of reduction that has involved him in a radical revision of painterly ends and means. Like Johns, his original motivating force was a dissatisfaction

on the philosophical level with the assumptions of conventional pictorial representation.

An obvious point in support of this claim can be made if we consider the general course of Rosenquist's recent career. It has already been shown that Johns' paintings gradually 'filled up' with objects from 1960 onwards, reaching a peak of 'inclusiveness' in 1964: from this point onwards, his work has been gradually drained of content. Rosenquist's recent work offers a directly parallel development, with the peak of inclusiveness occurring in in 1965, when his gigantic *F-111* was exhibited over the entire Leo Castelli Gallery. Since that stage, there has been a more or less progressive emptying of content. His astonishing *Fire Slide*, painted for Expo 67, was also of huge proportions. But while *F-111* contained a multiplicity of images, *Fire Slide* involved only one. (52) Rosenquist's recent paintings on transparent Mylar are quite simple conjunctions of two or three different objects.

However, the theme of this chapter is that the experimental approach of these three American artists cannot be explained merely in terms of content. Rosenquist's career must be shown to possess a consistent direction, which inevitably implies transformations of content, rather than vice versa. The clue to this direction may perhaps be found in the discovery which Rosenquist made in the winter of 1959-60: that he had managed to escape from 'that old pictorial space'. At first sight this may appear a perplexing remark, for Rosenquist often seems to render space in a traditional way. His application of paint through spray-gun technique allows him to achieve an impression of photographic accuracy. Yet this analogy with the photograph points in effect to the unconventional nature of Rosenquist's vision of space. It is through the superficially faithful photographic rendering of three-dimensionality that he reveals the ultimate vacuity of pictorial space.

Some important aspects of his procedure are evident in the lithograph *Circles of Confusion*, which dates from 1965-6. We must accept, of course, that the photographic rendering of the external world is highly selective in the sense that it merely records the incidence of light on objects. In *Circles of Confusion*, Rosenquist brings into relief the ambiguity of light as an index of visual reality. 'In a camera,' he explains, 'shiny objects in the foreground and background become soft round fuzzy balls on the photograph; they have a technical term, circles of confusion.' The purpose of this lithograph is therefore to demonstrate what he calls 'the paradox between the eye and the camera'. The photographic rendering is displayed as a mere convention, which will not necessarily concur with the findings of the eye, and under certain circumstances falls into incoherence.

We may well ask at this point why Rosenquist laboriously seeks to recreate a photographic rendering if he regards it as fundamentally imprecise. The answer is that he uses photographic effects *because* they are imprecise, and can be exposed as such.

The photographic image inevitably suggests to us an authentic representation of visual reality, much as the elaborate perspectival scheme must have done to the men of the Renaissance. By cunningly working up, and at the same time undermining, a photographic surface, Rosenquist is attacking one of our most entrenched visual conventions, and so making a point which can radically affect our relationship to the pictorial world. He effectively brings this issue to the fore in a comment on the painting *Front lawn*:

It's as if you have that picture in an empty wall space, then all the reasons for it are as below zero as I can get. *Front lawn* is a very empty picture for me, with a lot of very unnecessary stuff on the surface. The whole thing is a visual vestigial appendage towards an emptiness. Say that it's the difference between showing an empty canvas which is explicit, as opposed to this *Front lawn* which appears full of stuff but actually is even emptier than an empty canvas—because an empty canvas is so laboriously designed.

This slightly enigmatic passage gives several of the clues to Rosenquist's characteristic procedure, which can be analyzed in a number of stages. At the first stage, there is the complete rejection of the conventional props of painting ('that old pictorial space'). This gives rise to the firm conviction that the 'beyond' in painting is not to be regarded as inhabited space, but as emptiness. Yet the sensation of emptiness cannot be evoked by the superficial expedient of the empty canvas. In order to convey uninhabited space, Rosenquist must elaborate on the surface of the painting an illusory scheme just as complicated as was necessary to evoke inhabited space. He must devise a pattern which will veer between operating as a photographic image and revealing itself as 'unnecessary stuff on the surface'. As in the case of Jasper Johns, the destiny of the work is to achieve an ultimate vacuity which indicates that no prior assumptions have been allowed to stand. Rosenquist recalls Johns in making a close conjunction between the picture and the 'empty wall space'.

In spite of this similarity of doctrine, Rosenquist is effectively working towards a solution which is entirely different from that of Johns. The fact becomes clear when the single most important principle in Rosenquist's procedure is brought into relief. In his concentration on the simulated photographic surface, he is promoting a type of representation which is quite literally superficial, and so lends itself to being interpreted as 'unnecessary stuff'. His initial method of inviting us to draw this conclusion was to merge various types of surface into one another in a way that was obviously a contradiction of nature. In *Lanai* (1964), for example, the patterning of the curtain overlays the chrome fenders of an automobile and the damp gleam of a tinned peach. The implication is that, just as the surface patterning of the curtain harmonizes on a purely decorative level with other surfaces belonging to objects on vastly differing scales, so the seemingly substantial images of peach and car float in a kind of representational limbo

beyond which there is emptiness. It is none the less true that this picture, and others of its period, offer an overall impression of richness which tends to work against this interpretation. The various surfaces tend to become a self-sufficient decorative field, instead of cancelling out each other's authenticity and leaving us with a prospect of vacancy.

It is presumably as a result of this dilemma that Rosenquist has so radically pruned his stock of images since 1964. Rather than represent a complex pattern of interacting surfaces, he has attempted to obtain the closest possible identification between 'represented surface' and the actual surface of the work. In making them 'cohere' to a remarkable degree, he has found his solution to the problem of emptiness, since, by this method, the objects represented are made to appear inseparable from the conventional, two-dimensional surface.

We can see this purpose at work as early as the project for Expo 67. The overwhelming size of this picture prevents us from taking it in at one glance. When it was exhibited at the 1968 Kassel documenta, it occupied virtually the entire wall of the main stair-well. This brought out the connexion between the downward emphasis of the canvas and the vertiginous sensation of falling. In fact Rosenquist seems to have intended to make this close connexion between the actual dimensions of the work, the way it is perceived, and the actual subject. The feet clenched around the 'Fire Slide' are not so much objects in the round as indications of a precipitous downward movement, which seems to be barely arrested by the fixity of the canvas. Beyond this masterly identification of the picture's downward emphasis and the unchecked fall along the shining bar, there is indeed 'emptiness.'

Yet this is not quite the identification of actual surface and represented surface which was mentioned previously. Rosenquist has made use of the physical characteristics of the canvas, in the sense that he has employed the distinctive relationship that we have to a large vertical work. But he has not reached a solution which would apply equally to smaller and less physically assertive paintings. In effect, he could not resolve this problem of identification while the pictorial surface remained the highly ambiguous surface of the stretched canvas. It was necessary for the photographic treatment of the object to be paralleled in the very constitution of the work. In other words, it was necessary for the actual material which composed the surface to be visible as such only through the incidence of light.

This requirement is exactly fulfilled by the transparent material called 'Mylar' which Rosenquist used widely in 1968. A picture like *Scrab Oak* from this year demonstrates the subtlety of Rosenquist's achievement, and his striking success in carrying his ideas to their logical conclusion. In the first place, the application of paint on this transparent surface results in a temporary impression of extreme density and solidity. The block of butter, high-lighted, rests upon the knife-blade which also reflects it.

But even within this central image there is tension. The butter seems to be on the point of sliding off the knife-edge, not into pictorial space but into the infinitely receptive, light-catching—but unmistakable two-dimensional—surface of transparent plastic. The microphone poised to the left of the truncated knife completes, and to some extent steadies the composition, but only at the expense of breaking up the unity of the picture plane, since it belongs to another sheet of Mylar, suspended at an angle to the dominant plane. The fact that these sheets are, quite explicitly, hanging—rather than being fixed on wooden stretchers—tends to underline the provisional, evanescent nature of the deceptively concrete forms. (45)

In a sense we seem to have come full circle and returned to the transparency of Duchamp's 'delay in glass'. But there is a crucial difference. Rosenquist's images are not 'trapped' between two sheets of glass. They blend into the luminous surface of the medium, indicating an ambiguous and 'superficial' treatment of the object that is not a mere trick of artistry but a considered reaction to the final impossibility of representation: to the simultaneous requirement of presence and absence in the pictorial work of art.

It might be justifiable to attach a psychological explanation to Rosenquist's position in relation to visual reality. This approach would be supported by the following personal testimony: 'I have this idea about solid appreciation—realizing things but not really being attached, like renting everything I'm involved with, and so depersonalizing things.' Yet however much might be made of this connexion, and however much of the easy equation between Rosenquist's studied superficiality and the values of contemporary American society, it is in pictorial terms that his achievement must ultimately be seen. If Johns succeeds in establishing the picture as a substitute for the wall, and so redeems it as a vehicle, however imprecise, for the trace of the object, Rosenquist removes the pictorial surface from the wall, stations it in empty space, and allows the object to partake of its transparency. The physical presence perfectly underpins the metaphysical quest.

ROBERT RAUSCHENBERG

The process which I have described in the case of Johns and Rosenquist is no less clear in the work of Robert Rauschenberg. In his case, there is not simply a reduction from fullness to emptiness, a transition from presence to absence. A contrast can also be struck between the maximum presence of the object in physical terms at the outset, and the minimum presence in the most recent stage of his work. The objects from the external world which people his early 'combines' are displayed fully and without ambiguity, unlike the topsy-turvy, clustered and maimed objects incorporated by Johns. Yet in Rauschenberg's very recent work, there is not even a trace of the object left on the canvas.

It has become an evanescent shadow on a translucent surface.

To explain this itinerary, it is useful to make use of a concept which has already been applied in the case of Rosenquist. 'The empty canvas,' writes Rosenquist, 'is so laboriously designed.' Rauschenberg shares this tendency towards an emptiness that cannot be simply presumed, but must be carefully and laboriously created through attention to the pictorial surface. It is not the 'virgin' emptiness of the canvas which is untouched by the artist's hand, but an emptiness which testifies to the methodical elimination of content that the artist is engaged upon. In other words, it is the final outcome of a critical procedure which is based upon the contradictory status of representation.

An obvious point of departure in reviewing this procedure is the group of 'combine' paintings which Rauschenberg produced around 1960. As John Cage has noted, the essential point about these works is their lack of a unitary subject. The combine is, in Cage's words, 'a situation involving multiplicity'. And, as I suggested previously, this multiplicity is more challenging, more immediately divisive than in the case of Johns. A good example is *Pilgrim* (1960), in which the near to abstract canvas incorporates, on the lower right-hand side, an unexceptionable wooden chair. The chair in *According to What* is partly cut away, and lies upside down at an angle to the canvas. It is therefore doubly remote from its utilitarian origins. But Rauschenberg's chair is complete, and hovers slightly above the ground in an expectant attitude.

The late Anton Ehrenzweig once explained to me in a letter that this work by Rauschenberg could be compared with a Reinhart production of Goldoni's *The Servant of Two Masters*, in which chairs were painted on to the backcloth. 'The servant brought in also a "real" chair, but proceeded to sit down on a "painted" chair . . . Reinhard thus insisted that the painted chair was more real and promising of rest than the three-dimensional chair.' In Ehrenzweig's view, Rauschenberg was also using the 'real' chair to 'annihilate the difference between two and three dimensions'. This is a conception which adequately fits Ehrenzweig's critical notion of 'Enveloping Pictorial Space', where the discrete fragments of the work are fused together in an 'undifferentiated serial structure'.

An explanation of this kind is certainly permissible. And I would certainly agree with Ehrenzweig that 'once we have appreciated Rauschenberg's mastery over the "intact" painted surface we will begin (to see) the same "intactness" in the earlier work where the real objects seem to, but in fact do not, upset the painted surface.' Yet it will at least be granted that Rauschenberg's chair *alternates* between being sucked into the canvas, and appearing in its own right as an anarchic or problematic object. The very fact that Rauschenberg moved from his combines to a form of painting in which the surface remained 'intact' predisposes us to see the earlier stage as an anterior process in the assimilation of the object.

The series of works which Rauschenberg began after the combines employed the very distinctive technique of silk-screen to reproduce photographic material. Once again, as in the case of Rosenquist, the intention of using the photographic image is to expose the inadequacy of photography as a mode of representing reality. But while Rosenquist reckoned that by 1960 he had done away with 'that old pictorial space', Rauschenberg has continued to attack pictorial conventions through an explicit use of traditional spatial projection.

The distinction becomes clear if we compare Rosenquist's *Lanai* with Rauschenberg's *Bicycle* (1963). If Rosenquist challenges our confidence in the image by allowing contrasted textures and objects on different scales to knit together in a unified picture plane, Rauschenberg quite intentionally gives us a multiplicity of photographic images that bear no relationship to one another. At the same time, the 'old pictorial space' is continually alluded to, indicated and reproduced. To the right-hand side of *Bicycle*, a schematically drawn cube alludes to the fact that we automatically read a degree of spatial recession into such a figure. Beside this cube, a photographic rendering of Velasquez' *Rokeby Venus* indicates the conventions of perspective used in Post-Renaissance painting. Rauschenberg has chosen this picture advisedly, since the effect of the imagery is both to invite and to deny the illusion of real space. Venus does not face us directly, but contemplates her face in a mirror held by Cupid. Thus the point is made that pictorial space belongs primarily to the circumscribed world of the image: only in a secondary sense does it relate to the world and to our own standpoint. (54)

Rauschenberg has therefore taken the illusion of spatial projection as the crucial point at which the validity of pictorial conventions may be challenged. And this challenge does not simply apply to the perspectival convention upon which the majority of contemporary paintings continue to trade. It is also directed against the photograph as such, since photography itself offers a misleading picture of the real world. Rauschenberg exposes the conventional nature of photographic technique by conveying separately the various single colour stages which go to make up a full colour print or 'hektachrome'. In *Bicycle*, the helicopter at the top left-hand edge seems complete, since it has received the requisite number of overprintings. But in other places Rauschenberg allows just one dominant colour to be printed, or interrupts the image with a violent passage of paintwork. The net effect of this very diverse method of presentation is to display the photographic image for what it is—a product of various technical processes rather than a privileged glimpse into the world of actual events.

Of course this entire process is a comment not so much on the validity of photographic reproduction as on the question of illusion, and its relation to representation. Rauschenberg recognizes perfectly well that the human brain is predisposed to plotting out perspectival schemes and photographic images in spatial

terms—once it has received a preliminary conditioning. He considers that the task of the painter is to make us conscious of these dispositions, rather than to exploit them. Just as Rosenquist was anxious to show that the space implied in his *Front Lawn* was mere emptiness, so Rauschenberg forces us to conclude that the diverse prospects offered by these lush areas of pigment are quite illusory. In a curious way, his helicopters and yachts are abstract images for all their photographic detail, since their treatment and their context both tend to neutralize the implied space.

As early as 1961, John Cage was able to write about Rauschenberg: 'He changes what goes on, on a canvas, but he does not change how canvas is used for paintings—that is, stretched flat to make rectangular surfaces which may be hung on a wall.' This remark applies to Rauschenberg's work up to and including the silk-screen paintings, but not to his subsequent achievement. Inevitably, one might say, his exploration of the way in which we relate to the illusory world of the pictorial surface has impelled him to reinterpret the techniques through which that surface may be presented and composed.

As we have seen, Rosenquist's exploration resulted finally in the use of hanging sheets of transparent Mylar as his medium. In this way, the plane surface was maintained, but the other traditional features of the stretched canvas were abandoned. Rauschenberg has also reduced his medium to the transparent plane surface. But his plane surfaces are rigid, rather than collapsible, arranged in parallel sequence rather than juxtaposed at an angle, and, as far as his series of *Revolvers* goes, round rather than square. There is certainly nothing unprecedented about a painting in a circular format, as Rauschenberg emphasises by making Ingres' *Le Bain Turc* one of the most prominent images. But the situation is transformed by the fact that these circular discs actually revolve. In fact, the way in which the *Revolvers* are conceived suggests that Rauschenberg deliberately aimed to contravert the conventions which were still implicit in his silk-screen paintings. Not only are the images presented on several successive planes rather than on one opaque medium: it is also clear that the revolving planes prevent any definite conclusions about the 'right way' of viewing the work. It is no longer possible to speak of top or bottom, or to establish definitive links between images on different planes. (46)

The effect which Rauschenberg obtains with these circular overlapping planes is a curious one. We can no longer posit a space 'beyond', as with Rosenquist's works on Mylar. This is because the illusory space of each image extends into the surface schema of the next image, and so on. The result is a type of space which appears to be confined within the physical dimensions of the work, and is sufficiently incoherent to prevent any genuine sense of illusion. The multiplicity of images which was confined to one surface in the silk-screen paintings is now apparent through the density of parallel layers.

Yet it almost seems that Rauschenberg has defeated his own

object in creating so complex a piece of machinery. The *Revolvers* are very far from the informal, almost haphazard quality which Cage noted in his use of the canvas: 'singly, joined together, or placed in a symmetry so obvious as not to attract interest (nothing special).' What is more, they have lost the direct relationship to the wall—the ultimate neutral plane surface—which Rauschenberg had previously exploited to the full. It should be possible to see this departure as a significant change in style and method: indeed Rauschenberg's subsequent work confirms that the *Revolvers* series was a turning point in his career. But the full significance of this turning point only becomes clear if we consider the large work *Solstice*, which resolves some of the problems associated with the *Revolvers*.

Solstice, which was exhibited at the Kassel Documenta in the summer of 1968, retained the technique of parallel transparent surfaces overprinted with silk-screen images. But it was rectangular in format and, most important of all, it comprised a system of sliding doors which offered a pathway through the work to the spectator. In this way the incoherence of the *Revolvers* was effectively avoided. The spectator was invited to make his own exploration of the internal space which had previously been inaccessible. Each surface could be investigated directly, as well as through an indefinite number of intervening surfaces. (55)

Despite the fact that it can be 'penetrated' by the spectator, *Solstice* does not represent a radical revision of Rauschenberg's original ideas. Unlike Johns, whose investigations are concerned almost exclusively with the relation between object and plane surface, Rauschenberg probes the *distance*—both actual and illusory—between the work and the spectator. The effect of *Bicycle*, and indeed of *Pilgrim*, is alternately to attract and repel the spectator, first involving him in the spatial projection and then excluding him, whether this result is obtained through the problematic status of a chair or the self-absorption of the *Rokeby Venus*. *Solstice* brings the physical movement of the spectator himself into play, in order that he may modify his relationship to the variable density of images.

An interesting parallel occurs with the work of the Italian artist Pistoletto, who employed mirror surfaces in an exhibition at the Galerie Ileana Sonnabend, Paris, in 1967. (57) A room filled with the pictures of Pistoletto possesses an element of spatial ambiguity which is all-pervasive. We can accommodate the reduplication of images which naturally occurs as a result of the combination of mirror surfaces. But we have difficulty in placing the figures, objects and animals that stand equivocally on the threshold between our own space and the world of the mirrors. The ambiguity in *Solstice* is akin to this, in the sense that the images cohere to the smooth plane surface and appear reluctant to expand into the spatial dimension beyond. But in Pistoletto's work, the pictures are mirrors, and therefore restore to us the comforting perspective of the room in which we are standing. In *Solstice*, the

successive 'delays' accumulate, and between them there is emptiness.

With the two other American painters whose work has been considered in this chapter, the final stage has been a reduction of the work to a point where one single aspect predominates. In Rauschenberg's case the final reduction is not simply a matter of the work of art in isolation. He follows with scrupulous attention the principle enunciated by Duchamp: 'Les regardeurs font la peinture.' And since spectators 'make' the work, it is the relationship of the work to the spectator that must undergo this progressive process of reduction, to a point where Duchamp's metaphor becomes literally true. This is what occurs in the case of the work entitled *Soundings*, which was exhibited at the Museum of Modern Art, New York, in 1968, and subsequently visited several European cities.

The principle of *Soundings* requires a certain amount of detailed description, since it is by no means evident from photographs what is actually taking place. The work consists effectively of eight panels of coloured reflecting plexiglass, which are situated in the centre of a long room. When the spectator enters this room, there is no more than a vestige of reflection on the screens. But if any noise is made, the overhead microphones pick this up and set into operation a battery of strong lights that are concealed behind the screens. Since there are piles of white chairs intervening between these lights and the screens, the spectators are able to see a constantly shifting amalgam of the shadows of the chairs and their own intermittent reflections. (56)

Clearly this work belongs to the genre of environmental art which has exercised the ingenuity of many artists both in Europe and in the United States. One could draw a parallel between *Soundings* and the *Sonic Games Chamber* of Howard Jones, which also involves a combination of spectator movement, sound and artificial light. Yet the fact that Rauschenberg can now be seen within this new context should not prevent us from concluding that he has achieved a brilliant reduction—even if a *r eductio ad absurdum*—of the dilemma which we have been tracing. The chair, once a feature of *Pilgrim*, returns in *Soundings*. But now it is at the same time indubitably an actual chair, and a mere shade of a chair as far as the pictorial surface is concerned. This surface no longer has any reality except as a thin membrane between the known world of the spectator and the unknown world which his actions indirectly reveal.

Plato wrote in the *Republic* that dialectic was 'the only activity whose method is to challenge its own assumptions so that it may rest firmly on first principles'. The three American painters whose work has been discussed in this chapter share Plato's scepticism about the validity of artistic representation, yet the activity which they have adopted is dialectical in the Platonic sense. Whether the path which they have taken has led them out of the Cave and into the sunlight will perhaps remain an open question.

I

Conclusion

The various strands of enquiry which have been pursued up to this point leave us with a number of unanswered questions about contemporary painting in general. Is it still possible, and useful, to speak of 'experiment' in painting? Is it reasonable to insist upon the exclusiveness of painting as a genre? Lastly, and perhaps most important of all, is there any way of analysing in systematic terms the relationships between the 'paths' which I have presented as distinct?

If we begin by considering the first two questions, the problem becomes once again that of juxtaposing the attitudes of contemporary artists in Europe and America. As was suggested at the beginning of Chapter 5, the modern American painter is in a very real sense heir to the principles of the Modern Movement. A commitment to the series rather than the individual painting can be observed in the work of Frank Stella, just as in the case of Moholy-Nagy. Yet the American artist adopts the outward signs of the experimental approach only to challenge its essential assumptions. As Lawrence Alloway has pointed out, the custom of producing works according to a governing system or plan was in part a reaction against Abstract Expressionism, but it did not reflect a fundamental break with the immediate past: 'because of the intervening generation of exploratory artists, the systematic and the patient could be regarded as no less idiosyncratic and human than the gestural and cathartic. Only the defenders of the idea of classicism in modern life resisted this idea of the arbitrariness of the systemic.'

The rejection of order as an intrinsic value to which this passage testifies is not simply a matter of American artistic tradition. In Donald Judd's terms, it has philosophical and scientific implications. With reference to the 'rationalism' of European art, in particular that of Vasarely, Judd maintains: 'All that art is based on systems built beforehand, *a priori* systems; they express a certain type of thinking and logic that is pretty much discredited now as a way of finding out what the world's like.'

Judd's argument would presumably run as follows. The experimental tradition of the Modern Movement is based, like the notion of classicism, on rationalistic premises. It is modelled upon the example of the experimental sciences, in the sense that it takes as its basic premise the possibility of progress in rationally controlled circumstances. Yet this whole pattern of scientific discovery has been discredited by contemporary 'philosophers and scientists'. Therefore the artist should also abandon his reliance on '*a priori* systems'.

This critique of the experimental approach does not hold in universal terms. For one thing, the scientific model upon which most recent 'research' in the visual arts has been based is that of optics and experimental psychology. It would be foolish to pretend

that in these particular spheres the artist cannot make 'discoveries' as a result of rationally controlled experimental methods. But Judd is not really concerned with this level of activity. He is questioning the whole mode of thinking which regards such calculated discoveries as a sufficient objective. And here it must be conceded that the contemporary scientist is indeed persuaded of the limited validity of the experimental approach. He is aware that, as Louis de Broglie puts it with reference to quantal physics, an experiment involves 'a partly uncontrollable perturbation of what one wishes to measure'.

Yet this lack of an ultimate certainty in the scientific description of the physical world surely does not affect the aspect of experiment which science and painting may be said to hold in common. Broglie sees the scientist as 'no longer engaged in the passive contemplation of a fixed universe', but 'snatching from the physical world . . . certain information, always partial, which would allow him to make predictions that are incomplete, and in general, only probable'. Surely this is the very position of the experimental artist, committed to 'open' research? Indeed an artist like Vasarely, with his pronounced emphasis on the instability of structures, surely stands vis-à-vis the classicist in just the same relation as the modern to the nineteenth-century scientist.

But however easy it may be to point out the limitations of Judd's argument, it is undeniable that his objections to rationalism in artistic activity denote a widespread reaction which is already spreading beyond the boundaries of America. This is symbolized by the movement of Minimal art, which is often so close to the geometrical work of the Modern Movement in its superficial appearance, yet differs from this quite fundamentally in its insistent anti-rationalism.

If the American challenge to the experimental tradition can be seen most clearly in an anti-rational response to the vocabulary of the Modern Movement, the American revision of the notion of painting can be related to the Aestheticism of the nineteenth century. This is the argument of Lawrence Alloway, who relates to Whistler the 'idea of medium purity as operational self-criticism, on which American formalist art criticism still rests'. The most simple and most devastating principle to which this idea has given rise is the dictum of Clement Greenberg that 'flatness, two-dimensionality, was the only condition shared with no other art, and so modernist painting oriented itself to flatness'.

Perhaps the direct result of the popularity of this principle in a British context is the growing disrepute of painting as opposed to sculpture among younger artists. William Tucker, the sculptor, states: 'I think that sculpture has become a more complex kind of process, as painting has become more simple and definable.' This 'definability' of painting, which is surely a direct result of the American influence, can easily be equated with the suggestion that painting has relatively few problems to solve. David Annesley,

another young sculptor, substantiates the point: 'I think that painting is to do with illusory space and colour, and the problem in painting has boiled down to what colours to pick, how to pick them and where to put them. And what kind of space is produced and what it must be as a kind of indeterminate space.'

In one sense Annesley is restating—in a less cut and dried form than Greenberg—the various features which have always gone to make up a painting. But the main implication of his statement is that there is no longer any mystery in the conjunction of these features. For this reason, it is hardly surprising that the recent exhibition of the work of Magritte at the Tate Gallery should have aroused such interest among British art students. Magritte's subject is precisely the wonder, the mystery and the inconsistency of pictorial representation. His art focuses around the problematic character of the image. 'An image should not be confused with something tangible: the image of a pipe is not a pipe.' Through his wide-ranging investigations of perspective, surface and style, Magritte reverts continually to the dialectic of absence and presence which is the kernel of pictorial art.

My aim is not to imply a hierarchy of values according to which Magritte would be placed higher than the contemporary American painter. It is simply that a rigorous reduction of the premises of pictorial art, conveyed through the metalanguage of the artist or critic, will naturally result in a kind of impoverishment. Morris Louis is a startling and original painter, whose control of illusionistic depth could be discussed in terms that would also be applicable to Magritte. Yet the passage by Dore Ashton that was quoted previously implies the reluctance of critics to make this identification. One might say that the American criticism which uses categories such as event and fact to mark the distinctive status of the new art is ultimately self-defeating. You cannot hang an event on a wall: indeed there is very little that you *can* do with it in a pictorial context.

I should emphasize that I am not erecting 'illusion' and pictorial space as absolutes which do not vary according to time or place. As Vasarely has expressed it, we have to reckon with the 'innumerable pictorial "spaces" of the past'. Yet what is common to all these types of space is a subtle balance between what is there, on the surface, and what is implied or signified: between 'the plane' and 'something other than the plane'. Any variety of criticism which fails to take this ambivalence into account is bound to result in paradox.

It is only consistent with Vasarely's comment to ask where modern painting stands in relation to this shifting pattern of pictorial 'spaces'. Clearly there are many contemporary painters who still make use of the type of three-dimensional recession which has been characteristic of Western painting since the Renaissance. As Auerbach's drawings for the *Sitting Room* indicate, the painter is able to move away from the traditional perspective while retain-

ing the basic clues which enable us to identify a coherent space. But is there no other solution beside this variation on the 'old pictorial space' and the 'kind of indeterminate space' which David Annesley postulates?

In effect, there is another possibility which may acquire increasing importance in the future history of painting. Perhaps it should be considered not so much as a new departure as a reversion to a previous convention. Reference has already been made to Lissitsky's various categories of space, from 'planimetric' through 'perspectival' to 'imaginary'. At the outset, Lissitsky describes 'planimetric space' as arising directly from the 'physical two-dimensional flat plane': this distinguishes it from 'perspectival space', which places each element within a coherent three-dimensional scheme. If we define perspectival space in this way as a unified three-dimensional projection, then such painters as Vasarely and Rauschenberg both offend against it—Vasarely through purely compositional devices and Rauschenberg through mutually inconsistent images. Both introduce an element of unresolved spatial conflict which has the result of concentrating our attention on the picture plane.

Yet Vasarely and Rauschenberg are not exactly reverting to planimetric space, where elements are presented in series rather than in depth. They are closer to what Marshall McLuhan describes as the 'mosaic' approach: a series of 'static shots' or 'fixed points of view' in homogeneous relationship. It is an interesting comment on Judd's views that George von Bekesy, whom McLuhan quotes at length, should associate the mosaic approach with a lack of scientific certainty, with epochs when 'the framework is uncertain and the number of variables is large'.

This conception of a mosaic approach to pictorial space is a tool which serves well in the analysis of certain tendencies within the field of contemporary painting. As McLuhan emphasizes, the mosaic involves 'a muting of the visual as such, in order that there may be maximal interplay among all of the senses'. Such environmental schemes as Rauschenberg's *Soundings* might therefore be seen not as a threat to the very existence of painting, but as a corrective to the exclusively visual bias of the genre in the post-Renaissance tradition. However, this possibility brings us no nearer to the solution of the problem which was defined at the outset. Can there be any systematic analysis of the total field of modern painting covered in this study which does not stop short at the various conceptual boundaries that I have erected?

Clearly the notion of pictorial space alone provides too imprecise a basis for any such analysis. The same objection does not apply, however, to an examination of the relations of these various works to nature. Readers may have been aware of a certain elasticity in my use of this term. But this is due not so much to intrinsic ambiguity as to the fact that several specific types of relation are

involved. These I propose to classify in semiological terms, according to the tri-partite division of Charles Sanders Peirce.*

The first premise of my analysis is the identification of the relationship between the work of art and nature with Saussure's distinction between 'signifier' and 'signified'. This merely implies that the work of art, as a sign or collection of signs, necessarily involves a 'relation between two relata,' in the words of Barthes. Whether we posit nature as the 'structural process' of Biederman or the 'infinitely vaster' field of Vasarely, this relation is still there. The work exists not simply in terms of the syntactic grouping of its component elements, but also in relation to an external system.

Peirce's three classes of signs—the icons, indices and symbols—each involve a distinctive relationship between signifier and signified.† Peter Wollen concludes his study of the cinema with the happy realization that the film-maker 'is working in the most semiologically complex of all media, the most aesthetically rich'. He supports his claim with the example of Jean-Luc Godard, in whose hands 'the cinema has become an almost equal amalgam of the symbolic, the iconic and the indexical'. In the case of painting, such a claim could not possibly be made. Yet if the present state of the medium does not allow such richness of combination, it does permit a significant degree of shifting from one level to another. In part, this process of shifting corresponds to what I have called the 'paths' of experimental painting.

The iconic is clearly the traditional mode of the pictorial sign, since it implies a direct 'likeness' between signifier and signified. When the Abbé Dubos wrote in the eighteenth century that 'it is with natural signs that painting makes its imitations', he meant that, in contradistinction to the poet, the painter was able to employ signs which required no conventional backing. They were immediate and did not depend upon 'artificial' codification.

Modern aesthetics will not allow us to make so confident an assertion of the 'natural' element in painting—even eighteenth-century painting. But however much we may insist on the painter's role of translating natural stimuli, it remains clear that there is an immediate correspondence between signifier and signified in figurative painting—or, at least, in figurative painting up to a certain point in time. When we come to the work of Cézanne and his successors, a point of definition arises. How far can the painter

* The most accessible introduction to semiology, or the science of signs, is Roland Barthes' recently translated Elements of Semiology. As Barthes makes clear, Peirce's division of signs into icons, symbols and indices is simply one of several. But it is a division that lends itself particularly to the analysis of pictorial art. Peter Wollen has already demonstrated its applicability to the art of the cinema, and his stimulating work on Signs and Meaning in the Cinema provided the impetus for my own classification.

† The specific meaning of each of Peirce's terms will be clarified in the course of my illustrations. In simple terms, however, it can be stated that the icon (adj. iconic) is a sign by virtue of its likeness to that which is signified: the symbol (adj. symbolic) by virtue of a conventional agreement, and the index (adj. indexical) by virtue of an existential connection.

'geometricize' his rendering of the natural world without abandoning the iconic relationship?

Fortunately, Peirce's system provides for this dilemma. In his scheme, icons can be divided into two sub-classes: images and diagrams. In the case of the diagram, it is not the 'simple qualities', but the 'relations between the parts' that resemble one another. Here is a schema through which we can view the transition from 'traditional' figurative painting, through Cézanne, to Biederman and Baljeu. Biederman's insistence that the correspondence between the work and nature is not traditional, but on the level of 'structural process', is tantamount to a distinction between the image and the diagram. In Baljeu's terms, the tree consists of 'vertical and horizontal elements . . . with a large number of planes in between . . . in several spatial positions.' It is this relationship of a diagrammatic kind that the work of art seeks to recreate.

The relation implied by the *index* in Peirce's system is at once less directly identifiable and more intimate than the iconic. Roman Jakobson cites as examples of indexical relationships the footprint of Man Friday in the sand and medical symptoms such as pulse-rates and rashes. In other words, the index does not denote a likeness, but an *existential* connexion of one sort or another. Peter Wollen notes that the photograph, besides being iconic, is also indexical in the sense that it records the physical imprint of external phenomena. Clearly there is no direct analogy to the case of painting here. But painting can certainly possess an indexical dimension. I referred at an earlier stage to the 'vegetable density' of Courbet's pigment. In this case, the impact of the painting goes beyond the purely iconic, precisely because of this existential bond between the vegetable pigment and the woodland scene. Indeed the iconic element seems to have been deliberately played down—the forms left blurred and ill-defined—in order to stress the indexical element. Perhaps part of the secret of Courbet's 'Realism' might be explained in terms of this balance of two types of sign, which had already combined indissolubly in the art of photography.

If Courbet combines iconic and indexical elements in his representation of nature, many more recent painters have concentrated exclusively on the same type of indexical relationship, under the pretext of creating 'abstract' art. Vasarely appreciates this fact when he writes of the so-called 'lyrical abstraction': 'naturalistic figuration survives not in the identifiable forms of nature, but in the equivalences of naturalistic *matière*.'

If Courbet's indexical usage complements the iconic, and that of the lyrical abstractionist seeks to conceal it, there remains the possibility of a usage whose purpose is to testify to the absence of iconic reference. This is the case with the painting of Jasper Johns. In his works from around 1964, Johns associates actual objects with the pictorial surface: in other words, he introduces a confusion between the iconic and the indexical, the likeness and

the existential connexion. But he reduces these elements until he has confined himself to a series of 'traces', of utensils, materials, etc. In this way, the only signs employed at the final stage are indexical, but their presence causes speculation about the *loss* of iconic connexions.

Peirce's third type of relation, the *symbolic*, differs from the two preceding ones in that it requires the force of convention to establish its validity. It is a sign by 'contract', and involves neither analogical nor existential connexions between signifier and signified. Peter Wollen is anxious to expand Peirce's definition in this case, since he sees it as 'narrow and scientific'. But within the context of this study, the definition is adequate. It fits the type of relationship to nature implied in Vasarely's 'worlds which have up to now escaped the investigation of the senses'. For the connexion between the work and the worlds of chemistry and microphysics is not existential, nor could it be iconic, since these worlds are by definition unapproachable. It is a connexion which is genuinely symbolic, since the images of wave, field and corpuscle are in fact conventional symbols rather than likenesses for the microscopic world.

Despite the relevance of this category for Vasarely's recent work, it is quite clear that the symbolic representation of unknown worlds is not the only, or indeed the main feature of Vasarely's art. In my section on the path of abstraction, I was attempting to show that the interaction between the whole and its component elements could in itself be an object of aesthetic satisfaction. With Yvaral, for example, the symbolic element is virtually absent, and the spectator's attention is concentrated on analysing 'the relations of the real to the perceived'. Does this mean that the semiological categories which we have been using are unable to accommodate the kind of relationship between signifier and signified which seems to arise inevitably from the path of abstraction?

The answer lies in the fact that up to this point we have relied upon the *metaphoric* rather than the *metonymic* order, to use Jakobson's terminology.* We have considered the case of artists who are explicitly trying to achieve a particular relationship with nature, that is to say, with a highly complex system beyond the work itself. Now it is evident that in any deployment of signs, there must be an opposition between signifier and signified— between the syntagm and the system. But it is also evident that in certain forms of expression either the system or the syntagm

* Jakobson consigns to the metonymic order 'heroic epics', 'narratives of the Realist school', and films by Griffith, while the metaphoric includes Surrealist painting and the range of works associated with Romanticism. The distinction lies essentially in the fact that the structure of the former depends on connexions of a syntactic type, while the latter cannot be appreciated without reference to a system beyond the work itself. As emphasized below, the crucial difference between the syntagm (or syntactic order) and the system is that the former requires real space for its connexions.

predominates. In all the cases considered up to this point, there has been a strong metaphorical element: the predominance of the system over the syntagm has been evident from the constant reference to an external standard. But in Vasarely, and even more so in the case of Yvaral, the element of metonym predominates. That is to say, the system of geometrical forms from which the component elements of the work are drawn is comparatively banal. It is the way in which the work functions as a syntagm that is of interest: its role as a 'combination of signs, which has space for a support'.

While the majority of the painters discussed in this study can thus be seen in relation to a semiological scheme without much difficulty, there remain those whom I considered under the path of 'destruction'. Here there is an obvious need for additional concepts. Of course there does exist a relation between two *relata* in the cases of Giacometti, Bomberg, Auerbach and Andrews. This is of the straightforward iconic type, since we are rarely in doubt as to the 'likeness' which is being conveyed. But this relation is far less stable than in the previous cases. These artists are constantly probing the distance between the work and the outside world. What they are trying to represent is the problematic character of representation. Or rather, they do their utmost to convey the notion that system and syntagm cannot be programmatically divided. Hence their work to some extent transcends the semiological categories which we have been using, and depends upon what Barthes has described as a 'rhetorical' element.* To take one instance, the meaning of Michael Andrews' *The Garden Party* cannot be summed up in terms of a simple iconic relationship between signifier and signified. It depends on the fact that the artist, while retaining the iconic mode, has varied his composition in such a way as to make this variation a prime object of interest. It is precisely because the figures are not centrally arranged, but form a kind of vortex leading from the 'direct' representation of the right-hand figure to the obscurity of the far left-hand figure, that we are able to appreciate the painter's variable relationship to reality—his anxious concern to recreate 'the real thing'.

The three questions which I posed at the beginning of this section are to some extent answered. But there remains a more general question which emerges from the solutions which I have provided. What relevance have the various tendencies which I have isolated to the art of painting in the foreseeable future?

A problem which is particularly acute for the critic is the transition from the metaphoric to the metonymic order. As Barthes

* Cf. Roland Barthes, *Système de la Mode*, Section 17: 'Rhétorique du signifiant: la Poétique du vêtement.'

Barthes underlines that there is an element of rhetoric or 'poetic mutation', 'as soon as one passes from the real function to the spectacle, even when this spectacle disguises itself under the appearance of function.' In other words, the extent to which the sign, or structure of signs, diverges from its direct function is a measure of its rhetorical import.

underlines, the metalanguage of the critic is itself metaphorical and 'consequently homogeneous with the metaphor which is its object'. This homogeneity can result in a somewhat permissive type of art criticism in which the critic takes upon himself the role of filling in the details of the artist's supposed system: Vasarely's condemnation of the traditional artist 'flanked by his poet' points directly to this danger. And yet the problem of criticizing works of the metonymic order poses much greater difficulties. As Barthes remarks, the literature of metonymy is 'next to nothing'. It may well be that any trend towards metonym in contemporary painting will leave the critic with nothing to say, or at least force him to pay careful attention to Van Doesburg's glossary of 'words which do not concern painting'.

Are there any forces working against the predominance of metonym in contemporary painting? Within the metaphoric order, the mode of indexical reference can be dismissed straight away. It has its place in the work of Jasper Johns, but here its chief purpose is to signify the atrophy of the iconic mode. The use of the iconic clearly remains valid for a number of painters in this study, such as Biederman and Baljeu, who take the icon as diagram rather than image. But the more conventional usage of Auerbach and Andrews is entirely overshadowed by the rhetorical element: divergence from or variation on the iconic reference becomes the true subject of the picture. And this crisis of the iconic directly affects the symbolic sign, since symbolic reference has traditionally taken place within an iconic framework.

Yet it is perhaps near-sighted to confine our enquiry to the immediate field of painting, since the very introduction of semiological categories suggests at the least a certain withering away of the genre. However we may classify it, Ian Hamilton Finlay's *wave/rock* is a fine combination of the iconic and symbolic: it evokes a natural event in diagrammatic form, while drawing upon the area of symbolic reference which is language. (58) Painting may have lost the semiological richness which it traditionally possessed. But this does not necessarily imply that the types of sign previously employed in painting will not be extended and developed in another medium.

Bibliography of sources
used in the text

Introduction

GOMBRICH, E. H. *Art and Illusion* 2nd edition, London, 1962, p. 279
The Story of Art 9th edition, London, 1964
MOHOLY-NAGY See entry under Chapter I
REICHARDT, JASIA Introductory note to work of Peter Schmidt,
Studio International Nov. 1968
VASARELY *Notes, réflexions* Publication du Bureau Culturel de
l'Ecole Nationale Supérieure des Beaux-Arts, Paris

Chapter 1

ANDERSEN, TROELS 'Notes on Tatlin', in *Tatlin catalogue* Moderna
Museet, Stockholm, 1968
BILL, MAX 'Art as non-changeable fact', in *Data* (ed. Anthony Hill),
London, 1968
BURNHAM, JACK *Beyond Modern Sculpture—The effects of Science
and Technology on the Sculpture of this Century* Allen Lane,
London, 1968, p. 248 ff.
CONSTABLE, JOHN *Correspondence* (ed. R.B.Beckett), Suffolk
Records Society, 1964–, esp. Vol. II, pp. 270, 276; Vol. IV,
pp. 170–73; Vol. V, p. 68; Vol. VI, p. 77
See 'Constable and the Pursuit of Nature', in Nikolaus Pevsner,
The Englishness of English Art, London, 1964
COOPER, DOUGLAS 'Claude Monet', in *Monet catalogue*, Arts Council,
1957
DOESBURG, THEO VAN 'Elemental Formation', from *G*, trans.
Richard Taylor, in *Form* 3 Dec. 1966
'The Progress of the Modern Movement in Holland', from *Ray*,
Form 5 Sept. 1967
Numéro d'introduction du groupe et de la revue Art Concret
Paris, 1930
De Stijl Jan. 1932, p. 26
GABO, NAUM *Realistic Manifesto* reprinted in *Studio International*
April 1966
GERSTNER, KARL 'The tension picture. Case history of an artwork.
Artwork?', in *Data* (ed. Anthony Hill), London, 1968
GRAY, CAMILLA *The Great Experiment—Russian Art 1863–1922*
London, 1962
GROUPE DE RECHERCHE D'ART VISUEL Texts 1960–65, trans. Reg
Gadney and Stephen Bann, in *Image* Winter 1966
KOVACS, ISTVAN 'Totality through Light—The Work of Laszlo
Moholy-Nagy', in *Form* 6 Dec. 1967
LOHSE, RICHARD P. 'Elementarism. Series. Modulus.', in *Data* (ed.
Anthony Hill), London, 1968
MALINA, FRANK 'Some reflections on the differences between
science and art', in *Data* (ed. Anthony Hill), London, 1968

MOHOLY-NAGY, SIBYL *Moholy-Nagy: Experiment in Totality* New York, 1950

MUNARI, BRUNO Statement in *Art in Motion catalogue* R.C.A. Galleries, 1965

STOLZER, OTTO 'The preliminary course in Weimar and Dessau', in *50 years Bauhaus catalogue* Royal Academy of Arts, London, 1968

Chapter 2

BALJEU, JOOST 'Nature and Art since the Second World War', in *Structure*, 2nd series, 1, 1959
Attempt at a theory of synthesist plastic expression London (Alec Tiranti), 1963
'Syntetische konstrukties', *catalogue*, Stedelijk Museum, Amsterdam, 1969

BIEDERMAN, CHARLES *Art as the Evolution of Visual Knowledge* Red Wing, Minnesota, 1948
'Symmetry; Nature and the Plane', from *Structure* 3rd series, 1, 1960, condensed version in *Form* 4 April 1967
'A Non-Aristotelian Creative Reality,' from *Structure* 4th series, 2, 1962, condensed version in *Form* 4 April 1967
'Nature and Art', from *Structure* 2nd series, 1, 1959, condensed version in *Form* 3 Dec. 1966
'Sphere and Cube', from *Structure* 6th series, 1, 1964, condensed version in *Form* 3 Dec. 1966
'Art and Motion', from *Structure* 2nd series, 2, 1960, condensed version in *Form* 3 Dec. 1966
Letter to Michael Wilson, in *Form* 3 Dec. 1966
Art Credo, *Poor. Old. Tired. Horse* 22 (1967)

DENIS, MAURICE *Du symbolisme au classicisme—Théories* (ed. Olivier Revault d'Allonnes), Collection Miroirs de l'Art, Paris, 1967, p. 178

DIDEROT, DENIS *Sur l'art et les artistes* (ed. Jean Seznec), Collection Miroirs de l'Art, Paris, 1967, p. 50

HELION, JEAN 'Poussin, Seurat and double rhythm', in *Axis* 6 1936

HILL, ANTHONY 'Constructions, Nature and Structure', in *Structure* 2nd series, 1, 1959

LISSITSKY-KUPPERS, SOPHIE *El Lissitsky—Life, letters, texts* London, 1968

PETRONIUS *Satyricon* (trans. Paul Dinnage), London, 1963, p. 101

SCHWITTERS, KURT 'Art and the Times', from *Ray* reprinted in *Form* 5 Sept. 1967

Chapter 3

ARP, JEAN *Jours effeuillés*. Poémes, essais, souvenirs 1920–1965, Paris, 1966

BARTHES, ROLAND 'The activity of Structuralism', from *Essais critiques*, 1964, trans. Stephen Bann, in *Form* 1 Summer 1966

GROUPE DE RECHERCHE D'ART VISUEL Texts, Galerie Denise René, Paris, April 1962
See also entry under Chapter I

JAFFE, HANS 'De Stijl and Architecture', in *Form* 5 Sept. 1967

LASSUS, BERNARD Texts 1959–64, duplicated copies published by Maison des Beaux-Arts, Paris
'Visual Environments and Total Landscape', in *Form* 5 Sept. 1967
La Coudoulière Etude d'Ambiance, Centre de Recherche d'Ambiance, Paris, July 1968
See also other publications of the same centre (80 Rue Vercingétorix, Paris 14)

MOLES, ABRAHAM 'Vasarely and the triumph of Structuralism', in *Form* 7 March 1968

MOLNAR, FRANCOIS 'Towards science in art', in *Data* (ed. Anthony Hill), London, 1968

MONDRIAN, PIET 'Natural Reality and Abstract Reality—An essay in dialogue form', 1919–20, reprinted in Michel Seuphor, *Piet Mondrian—Life and Work* New York and London, 1957

RILEY, BRIDGET Interview in *The Times* 19 April 1965

VASARELY, VICTOR *Notes, réflexions* Publication du Bureau Culturel de l'Ecole Nationale Supérieure des Beaux-Arts, Paris
Vasarely Texts by the artist, including many from the previous collection, with preface by Marcel Joray, Neuchâtel, 1966

VASARELY and YVARAL *Catalogue* Galerie du Centre Culturel Municipal, Villeparisis, 1968 (includes Vasarely's 'Formel-informel', 1956; notes covering the period 1964–67; statements by Yvaral)

Chapter 4

ANDREWS, MICHAEL 'Notes and Preoccupations', in *X*, Vol. 1, No. 2, March 1960

AUERBACH, FRANK 'Fragments from a conversation', in *X*, Vol. 1, No. 1, Nov. 1959

BACON, FRANCIS Interview with David Sylvester, *Sunday Times* colour section, 14 July 1963
Interview with Michael Peppiatt, *Cambridge Opinion* 1964

BOMBERG, DAVID Notes in *X*, Vol. 1, No. 3, Summer 1960

GENET, JEAN *L'atelier d'Alberto Giacometti* Paris, 1963

GIACOMETTI, ALBERTO *Catalogue*, Galerie Beyeler, Basel, 1963
On Derain (1957), reprinted in *Derain catalogue* Arts Council, 1967

LOBET, MARCEL *J-K. Huysmans, ou le Témoin écorché* Paris, 1960

METZGER, GUSTAV *Autodestructive art* expanded version of talk

given at the Architectural Association, 24 Feb. 1965, A.C.C., London, June 1965
PECKHAM, MORSE 'Towards a theory of Romanticism', in *Studies in Romanticism* Vol. 1, No. 1, Autumn 1961

Chapter 5

ASHTON, DORE New York Commentary (on Morris Louis), in *Studio International*, Sept. 1968
BARTHES, ROLAND *Essais critiques* Paris, 1964
CAGE, JOHN 'Jasper Johns: Stories and Ideas', in *Johns catalogue* Whitechapel Gallery, London, Dec. 1964
'On Robert Rauschenberg, Artist, and his Work', in *Silence* 2nd paperback edition, Cambridge, Mass., and London, 1967
COLEMAN, ROGER Introduction to first 'Situation' exhibition (1960), reprinted in *Situation catalogue* Arts Council, 1962
DUCHAMP, MARCEL *The Bride stripped bare by her bachelors, even* (typographical version by Richard Hamilton: trans: George Heard Hamilton), London, 1960
KRAUSS, ROSALIND 'Jasper Johns', in *The Lugano Review* Vol. 1/2, II, 1965
LIPPARD, LUCY R. *Pop Art* London, 1966, p. 115 (Rosenquist)
MASHECK, JOSEPH London Commentary (on Frank Stella), *Studio International* Feb. 1969
O'HARA, FRANK 'Introduction and Interview', in *Franz Kline catalogue* Whitechapel Gallery, London, May-June 1964
PLATO *The Republic*, trans. H.D.P.Lee, London, 1958, p. 302
SOLOMONS, ALAN R. 'Jasper Johns', in *Johns catalogue* Whitechapel Gallery, London, December 1964
SWENSON, GENE 'Social Realism in blue—an interview with James Rosenquist', in *Studio International* Feb. 1968

Conclusion

ALLOWAY, LAWRENCE 'Systemic painting', in *Minimal Art* (ed. Gregory Battcock), London, 1969
ANNESLEY, DAVID, and TUCKER, WILLIAM Conversation in *Studio International* Jan. 1969
BARTHES, ROLAND *Elements of Semiology* (trans. Annette Lavers and Colin Smith), London, 1967
BROGLIE, LOUIS de *Physics and Microphysics* New York, 1960, p. 131
FOLKIERSKI, W. *Entre le classicisme et le romantisme* Cracow/Paris, 1925 (Abbé Dubos, p. 176)
GLASER, BRUCE 'Questions to Stella and Judd', in *Minimal Art* (ed. Gregory Battcock), London, 1969
MCLUHAN, MARSHALL *The Gutenberg Galaxy* London, 1967, p. 42
MAGRITTE, RENE *Catalogue* Tate Gallery, 1969, p. 84
WOLLEN, PETER *Signs and Meaning in the Cinema* London, 1969

Index

Figures in italic refer to the plates between pages 64 and 113